THE NEWARK MUSEUM COLLECTION OF AMERICAN ART POTTERY

ULYSSES G. DIETZ

The Newark Museum
Newark, New Jersey
1984

This publication has been supported by grants from the National Endowment for the Arts and the Geraldine Rockefeller Dodge Foundation. Their generous sponsorship is gratefully acknowledged.

© 1984 The Newark Museum
Published 1984.
The Newark Museum
49 Washington Street
P.O. Box 540
Newark, New Jersey 07101

Designed by Johnson & Simpson,
Newark, New Jersey

Type set by Elizabeth Typesetting Company,
Kenilworth, New Jersey

Printed by Princeton Polychrome Press,
Princeton, New Jersey

Photographs by Sarah Wells

Library of Congress Cataloging in Publication Data
Newark Museum.
 The Newark Museum collection of American art pottery.
 Bibliography: p.
1. Pottery, American–Catalogs. 2. Decoration and ornament–Art nouveau–Catalogs. 3. Pottery–19th century–United States–Catalogs. 4. Pottery–20th century–United States–Catalogs. 5. Pottery–New Jersey–Newark–Catalogs. 6. Newark Museum–Catalogs.
I. Dietz, Ulysses G. (Ulysses Grant), 1955–
II. Title.
NK4007.N48 1984 738'.0973'074014932 84-4818
ISBN 0-932828-19-1 (pbk.)

CONTENTS

Foreword 6

Acknowledgments 7

Introduction 9

Catalogue of the Collection

Auman Pottery 12
Biloxi Art Pottery 18
Charles Fergus Binns 20
Charlotte Brate 21
Bybee Pottery 21
Byrdcliffe Pottery 22
California Faience 24
Ceramic Art Company 26
Chelsea Keramic Art Works 27
Clewell Metal Art 27
Clifton Art Pottery 28
Cowan Pottery 38
Russell G. Crook 38
Ellen W. Cushing 39
Dedham Pottery 40
Deerfield Pottery 41
Durant Kilns 42
Faience Manufacturing Company 44
George Francis Frederick 46
Fulper Pottery Company 47
Greenwich House Pottery 64
Grueby Pottery Company 66
Hampshire Pottery 68
Inwood Pottery Studios 69
Lenox China 70
J. and J.G. Low Art Tile Works 70
Marblehead Pottery 72
Marqu Potteries 73
Moravian Pottery and Tile Works 74
Mott Pottery Works 80
Mueller Mosaic Tile Company 81
Anne Wells Munger 81
Newcomb College Pottery 82
Niloak Pottery 84
Odell and Booth Brothers 85
Old Dover Pottery 86
Omar Khayyam Pottery 87
Ott and Brewer 88
C. Pardee Works 89
Paul Revere Pottery 90
Pewabic Pottery 93
Poillon Pottery 94
Providential Tile Works 95
Red Wing Pottery 96
Adelaide Alsop Robineau 96
Rookwood Pottery 100
Roseville Pottery 111
Paul Saint-Gaudens 112
School of Mines 114
Tiffany Pottery 114
Trent Tile Company 114
Union Porcelain Works 115
Van Briggle Pottery 116
Volkmar Kilns 120
William Joseph Walley 122
Frederick E. Walrath 122
Weller Pottery 123

Selected Bibliography 125

The Arts and Crafts movement redefined European and American perceptions of the decorative arts and their interrelationship with everyday life. A special flowering of this aesthetic was the art pottery movement, as interpreted by the individual men and women who combined art and technology in a new and unique way.

John Cotton Dana, who founded the Newark Museum in 1909, was particularly suited to appreciate art pottery. Fascinated by American crafts and artistic design, in 1911 he began to assemble what has become one of the oldest, best documented and most comprehensive collections of art pottery in the United States. The Newark Museum collection now encompasses over three hundred pieces by sixty makers and includes examples of work by nearly all the most celebrated potters.

We are indebted to the National Endowment for the Arts and to the Geraldine Rockefeller Dodge Foundation for their support which has enabled us to mount the first complete exhibition of this seminal Newark Museum collection during 1984, our seventy-fifth anniversary year. Their funding has also made it possible for us to publish this fully-illustrated catalogue, the first such record of these distinguished holdings. I congratulate Ulysses Dietz, Curator of Decorative Arts, for his scholarship in compiling this volume. We hope that it will serve as a valuable and lasting reference for all who are interested in this expression of an American aesthetic.

Samuel C. Miller
Director
The Newark Museum

I am indebted to Gay Mahaffy Hertzman, Assistant Director of the North Carolina Museum of Art, for making contact with Nancy Sweezey, who at long last identified our collection of "Clay Crafters" pottery as the work of the Auman Pottery of Seagrove, North Carolina.

Special thanks are also due to all of the Newark Museum staff who encouraged and supported me in this project: Elizabeth Kopley, who polished the vital grant applications; Mary Sue Sweeney and her volunteer Julia Kluth, who pored over the manuscript with me and offered valuable suggestions as to style and form; Ruth Barnet, who typed the manuscript, and to Samuel Miller, who has given constant encouragement.

And of course, sincere thanks to the Geraldine Rockefeller Dodge Foundation and the National Endowment for the Arts, without whose generous support this publication would not have been possible.

Ulysses G. Dietz
Curator of Decorative Arts
March, 1984

Entries are given in alphabetical as opposed to chronological order. Throughout the entries, glazes are glossy unless specifically noted otherwise (satin or mat). The measurement of diameter ("D.") indicates the widest dimension of the object. Overall width ("O.W.") indicates the inclusion of any protruding handle from the body of an otherwise round object. All marks listed are on the bottom of the object unless otherwise noted. The University of Chicago Press author-date system of documentation has been used for text references to secondary sources. These references are keyed to the Selected Bibliography which appears at the end of the volume, in which all secondary sources are listed in alphabetical order.

The Arts and Crafts movement began in England in the 1870s under the influence of aesthetic reformers such as Charles Eastlake and William Morris. The ideals espoused by these reformers focused on hand craftsmanship and honesty of form and decoration. By the end of the nineteenth century, the styles promoted by the aesthetic reformers had been swallowed up in mainstream commercial design and had lost their original freshness. Continually evolving interest in the Orient and in the ancient world as well as the growth of the Art Nouveau style on the Continent provided new directions for design in England and America. Classically simple forms and simplified two-dimensional decoration began to replace the complex ornament and form of the aesthetic reformers. An earthy, consciously handmade style developed in America under the guidance of men such as Elbert Hubbard and Gustav Stickley, both of whom supervised the production of complete lines of household goods which adhered to their principles of craftsmanship.

The widest-ranging aspect of the Arts and Crafts aesthetic in America was in the field of ceramics. Skilled designers and craftsmen, trained in traditional ceramic production in Europe and America, adopted Arts and Crafts ideals and became innovators in design and technology. They produced an astonishing variety of pottery between 1875 and 1940, starting with the Victorian Japonism of the 1870s and

evolving through the Art Nouveau and Arts and Crafts styles into the modern styles of the 1920s and 30s.

Art pottery was as diverse as its makers. Some of the pottery was thrown on wheels, some cast in molds, and some built by hand. Fine porcelaneous clays as well as heavy stonewares were used. Decoration included modeling or painting the surface with naturalistic or stylized designs, as well as the use of carefully controlled glazes which often took years to perfect. Both women and men were art potters, although in many cases women tended to be more involved with the design and decoration than with the potting itself, a carryover of the Victorian ideas of what was appropriate for a woman to do and still remain a lady.

American art potters became world renowned for their work. Even in the larger pottery firms the craftsmen and women were closely linked with their product in a way that was unique to the era. The potter was transformed from an artisan to an artist, from an anonymous thrower or decorator into an individual whose name was linked to every piece he or she made.

In its heyday, art pottery epitomized the notion of the *decorative* arts: it was artistic, but above all it was useful. Even the most academic potters saw their works as household objects, albeit objects elevated above the

ordinary through careful design and fine craftsmanship. Vases were unabashedly vases, and almost everything produced had some relatively mundane household function.

Pottery today, like much of the decorative arts, has moved in a direction that in some cases removes it from the purview of the decorative arts curator and into that of the fine arts curator. This is in sharp contrast with even the loftiest of the art potters' ideas. Perhaps Adelaide Robineau's more spectacular carved pieces were never actually intended for use as vases, but they did in fact look like vases, or jars, or urns. The potters influenced by the Arts and Crafts movement rejected what they considered to be inappropriate ornament, but they did not reject the domestic nature of their wares. To place these pieces on pedestals and spotlight them as sculpture would have seemed odd to many of the potters, although they would certainly be flattered that their work is now held in such esteem. When viewing art pottery today, we should remember that it is almost always seen out of context. We should imagine each piece in its domestic setting, whether as a vase filled with cattails, one sitting empty on a mantel with five other vases, or even stored in a pantry closet awaiting its next use. This will bring us closer to an understanding of what the original producers and consumers of these wares saw, and why they wanted art pottery in their homes in the first place.

During its first years the Newark Museum housed no decorative arts collection as such. The institution was founded in 1909 with a collection of oriental objects. In 1910 and 1911, medals, tokens and coins supplemented the growing body of oriental material displayed in the Museum galleries on the fourth floor of the Newark Free Public Library's neo-Renaissance palazzo on Washington Park. But in 1911 a new category of object appeared in the accession files; a molded and glazed red clay tile produced by the Moravian Pottery. This title, called *Persian Antelope,* was given the number 11.429, and thus became the first object in the now enormous Decorative Arts Collection.

Persian Antelope was one of a large group of tiles donated to the Museum by the Moravian Pottery, Henry Chapman Mercer's unique operation in Doylestown, Pennsylvania. It was a fitting beginning for the Decorative Arts Department, since Dr. Mercer's views regarding handcraft and design closely paralleled those of John Cotton Dana, the Newark Museum's founder and first director.

The Mercer tiles were but part of a diverse collection of contemporary ceramics brought to the Museum rooms in November, 1910, for the exhibition of *Modern American Pottery.* Other potteries included in this landmark exhibit were Rookwood, Grueby, Walrath, Newcomb, Paul Revere, Van Briggle, Hampshire, Clifton, Marblehead, Volkmar and

Lenox. Although to today's art pottery afficionado this last maker may seem an unlikely cohort, Walter Scott Lenox was considered a great craftsman, and his work with porcelain earned him a place in Dana's pantheon of important potters.

Throughout this early collecting era, which included the historic *Clay Products of New Jersey* exhibition of 1915, Dana added important pieces by potters such as Adelaide Robineau, Charles Binns, Charles and Leon Volkmar and Arthur Baggs. He also acquired European examples to demonstrate the worldwide importance of ceramics as a facet of modern design and craft. The parallels and differences between American and European art pottery are demonstrated in Newark's collection, although this volume deals only with the American wares.

The Museum's collecting since World War II has reflected the flourishing of the studio potter, of the individual potter as opposed to the semi-commercial or large-scale concern. In recent years each Decorative Arts curator has acquired examples of the pre-World War II potters to fill gaps, as well as pieces by contemporary craftsmen. Important recent purchases represent those potters who gave the initial impetus to the art pottery movement in America. From the 1870s on, potters who were inspired by ancient, oriental and French ceramics all played seminal roles in the development of American pottery: makers like the Robertsons at Chelsea and Dedham; Rookwood in its early years, and even the studios which produced high-Victorian art porcelains

such as Ott and Brewer of Trenton. However far removed the subtle, earthy works of William Grueby seem from Ott and Brewer's Japanesque belleek wares, they both form part of a tradition that continues to evolve today.

Because of its unique early outlook on the Arts and Crafts, the Newark Museum became a mentor to art potters from the institution's start. The result is one of the broadest-ranging and most complete collections in the country. This volume is not intended as a treatise on art pottery. Other authors have written extensively on this topic, and a selected bibliography is included here. This catalogue of the Newark Museum collection, it is hoped, will serve as a useful source for scholars, collectors and laymen alike.

Not all of Newark's pieces are masterpieces in the modern collector's sense—Dana's acquisition philosophy usually favored the unpretentious and the attainable—but then again, many are. Every object exemplifies the aesthetic and the craft ideals of its maker, whether the eccentric George Ohr, the perfectionist Adelaide Robineau, or the academic (and commercially astute) William Hill Fulper II. The Newark collection stands as testimony to John Cotton Dana's foresight and to the vital role of ceramics in American decorative arts.

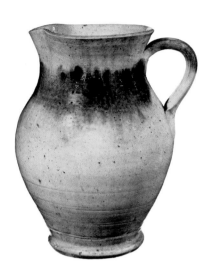
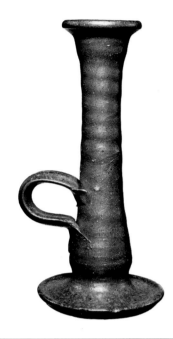
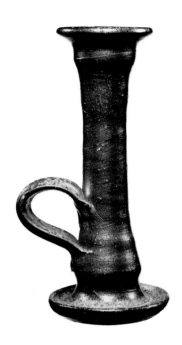

1.
Pitcher

Auman Pottery, Seagrove, N.C.,
1922-26

Buff earthenware body, ovoid
form with flared lip and applied
loop handle; overall yellow glaze
with blue brush marks at neck
and handle

H. 9¾"; O.W. 8"

Unmarked

Purchase 1927
27.330

In 1927 the Newark Museum
purchased thirteen pieces of
pottery from Clay Crafters at 119
West 40th Street in New York.
Until recently the exact identity
of the pottery has been
unknown. Clay Crafters was the
trade name of the art pottery
line produced at the Auman
Pottery in Seagrove between
1922 and 1933, run by Charlie
Auman. Just as the Busbees of
the Jugtown Pottery had
maintained a New York tearoom
to sell their wares, so did
Charlie Auman maintain the Clay
Crafters showroom in New York.
The plain forms and simple,
traditional glazing techniques
link Auman wares to other North
Carolina potteries, but the
distinctly classical forms of some
of the pieces relate to the
mainstream art potteries and the
movement's emphasis on
handiwork and forthrightness.

2.
Candlestick

Auman Pottery, Seagrove, N.C.,
ca. 1922-26

Tan stoneware, columnar form
on flat base with applied loop
handle and drip ring; salt-glazed

H. 9"; D. 4"

Unmarked

Purchase 1927
27.340

3.
Candlestick

Auman Pottery, Seagrove, N.C.,
ca. 1922-26

Tan stoneware, columnar form
on flat base with applied loop
handle and drip ring; salt-glazed

H. 8"; D. 3¼"

Unmarked

Purchase 1927
27.341

4.
Vase

Auman Pottery, Seagrove, N.C.,
1922-26

Tan stoneware, sharply tapered
classical baluster form with
narrow neck and wide flared
rim; overall yellow glaze with
splashes of cobalt blue on
shoulder

H. 11½"; D. 6¼"

Mark: Museum tape with
Claycrafters in ink

Purchase 1927
27.334

5.
Vase

Auman Pottery, Seagrove, N.C.,
1922-26

Buff stoneware, sharply tapered
classical baluster form with
narrow neck and wide flared
rim; exterior partly salt-glazed,
interior glazed brown

H. 7¾"; D. 5"

Unmarked

Purchase 1927
27.331

6.
Vase

Auman Pottery, Seagrove, N.C.,
1922-26

Buff earthenware, baluster form
with applied loop handles;
overall orange-yellow glaze

H. 9"; O.W. 8¼"

Mark: Museum tape with
Claycrafters in ink

Purchase 1927
27.332

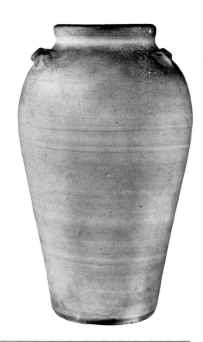

7.
Rose Bowl

Auman Pottery, Seagrove, N.C.,
1922-26

Buff earthenware, rounded form
with molded foot and rolled rim;
overall yellow glaze with
splashes of cobalt blue on
shoulder

H. 5½"; D.7"

Mark: circular paper label
reading *Claycrafters*

Purchase 1927
27.334

8.
Vase

Auman Pottery, Seagrove, N.C.,
1922-26

Light red stoneware, ovoid form
with short neck and three
pinched protrusions on
shoulder; partly salt-glazed

H. 10½"; D. 6¼"

Mark: paper label reading
Claycrafters NYC

Purchase 1927
27.335

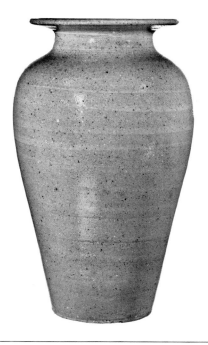

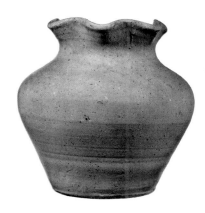

9.
Vase

Auman Pottery, Seagrove, N.C.,
1922-26

Grey stoneware, classical
baluster form with sharply
tapered base and wide flared
rim; salt-glazed

H. 9¼"; D. 6"

Unmarked

Purchase 1927
27.336

10.
Vase

Auman Pottery, Seagrove, N.C.,
1922-26

Grey stoneware, broad ovoid
form, sharply tapered at base
with flared crimped rim; salt-
glazed

H. 6¾"; D. 6¾"

Mark: tape reading *Claycrafters*

Purchase 1927
27.337

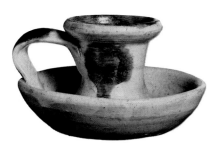

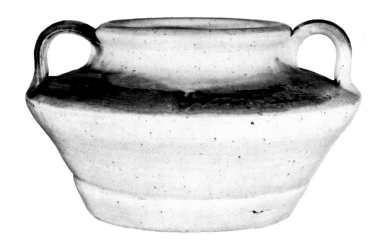

11.
Chamberstick

Auman Pottery, Seagrove, N.C.,
1922-26

Buff earthenware, dish form
with candle socket at center and
applied loop handle at side of
socket and rim; overall yellow
glaze with splashes of cobalt on
socket and handle

H. 3¼"; D. 5½"

Mark: tape reading *Claycrafters*

Purchase 1927
27.338

12.
Vase

Auman Pottery, Seagrove, N.C.,
1922-26

Buff earthenware, squat form
with flat shoulder and tapered
base with two applied handles at
rim; overall yellow glaze with
cobalt splashing on shoulders
and handles

H. 4¼"; D. 7¼"

Mark: tape reading *Claycrafters*

Purchase 1927
27.339

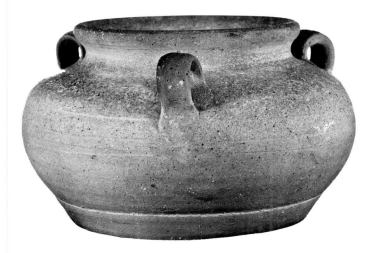

13.
Vase

Auman Pottery, Seagrove, N.C.,
1922-26

Tan stoneware, squat round
form with raised, slightly flared
neck and three small loop
handles applied on shoulder;
largely unglazed with speckling
of salt glazing on shoulder and
brown-glazed interior

H. 4½"; D. 7"

Unmarked

Purchase 1927
27.342

14.
Vase

Biloxi Art Pottery, Biloxi, Ms., 1890-1910

Executed by George E. Ohr

White earthenware, bulbous form with cylindrical collar neck; clear glaze with green and blue splashing

H. 3"; D. 3½"

Mark: incised signature *G.E. Ohr*

Purchase 1973
John J. O'Neill Bequest Fund
73.72

15.
Vase

Biloxi Art Pottery, Biloxi, Ms., 1890-1910

Executed by George E. Ohr

Buff earthenware, baluster form, thinly thrown, crumpled or folded clockwise at rim and crumpled at midpoint, on a molded foot; translucent green mottled glaze on upper half with burned oxblood glaze on lower section

H. 8"; D. 5½"

Mark: impressed
GEO.E.OHR/BILOXI MISS

Purchase 1982
Sophronia Anderson Bequest Fund
82.27

"Without question the most controversial art pottery produced anywhere in the world was executed by George E. Ohr at Biloxi, Mississippi" (Evans 1974, 27-31). Ohr established his pottery about 1883, and worked at it aided only by his son (who did no glazing or potting) until his death in 1918. His extra-ordinarily thin walls, never achieved by any other American potter, and bizarre crumpled forms made him notorious in his day. His unique glazes also lend great interest to his work, as demonstrated by this extremely fine example.

16.
Teapot

Biloxi Art Pottery, Biloxi, Ms., 1890-1910

Executed by George E. Ohr

Buff earthenware body, crumpled globular form with twisted handle and spout; overall nacreous black glaze, slightly uneven

H. 5½"; W. 7¼"

Mark: impressed
GEO.E.OHR/BILOXI MISS

Purchase 1982
Sophronia Anderson Bequest Fund
82.26

The rarest of forms of "the mad potter of Biloxi's" wares are the tablewares, many of which are functionally problematic. The loosely-fitting top of this teapot, for example, makes it of questionable usefulness. Although they fascinated and impressed scholars like Edwin A. Barber, forms like these may have repelled connoisseurs like John Cotton Dana, who never purchased a piece by Ohr for the Museum collections. Ohr considered himself the greatest living potter, heir to the throne of the Renaissance potter Palissy. Regardless of aesthetic judgment, Ohr's work stands as some of the best technical production to ever come off a potter's wheel.

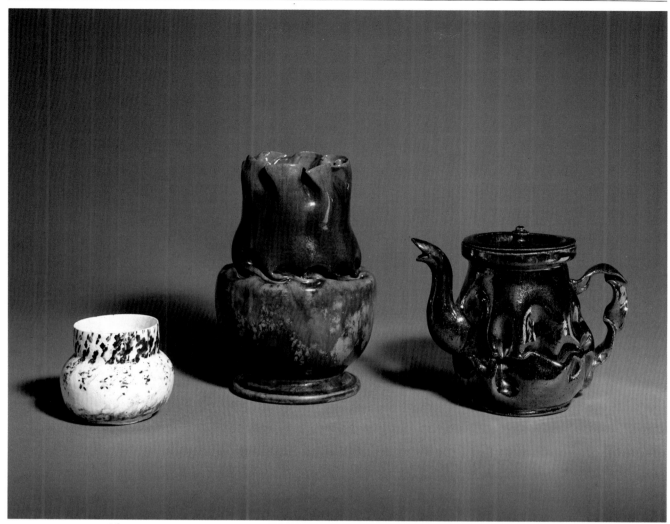

14 15 16

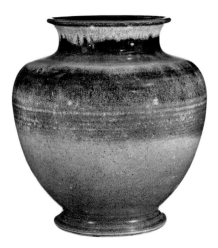

17.
Vase

Charles Fergus Binns,
Alfred, N.Y.,
ca. 1924

Buff earthenware body, broad
baluster form with tapered base
and wide, raised flared neck;
overall satin glaze of mottled
brown, olive, dark blue and
black

H. 10¾"; D. 9½"

Marks: incised *C.F.B./1924*; two
plain paper labels reading *$75*
and *BINNS #3*

Purchase 1926
26.20

The Museum bought this piece
along with its large Robineau
vase at the Pottery Shop in New
York. The high price indicates
Binns' importance in pottery
circles. The founder and
director of the New York State
School of Clayworking and
Ceramics at Alfred, New York,
Binns influenced numerous
important potters through his
work there. Adelaide Robineau
worked under him at Alfred. In
1914 the Museum borrowed a
pottery process display from
Binns for the *Clay Products of
New Jersey* exhibition.

18.
Charger

Charlotte Brate,
Long Island, N.Y.,
ca. 1936-37

Buff earthenware body with
curved flared brim and raised
foot; heavy overall glaze of
volcanic blue-black

H. 3½"; D. 15"

Marks: incised *CB* and *H.S.A.*
Gift of the Newark Art Club 1937
37.106

As the art pottery movement
drew to a close, Charlotte Brate
and other studio potters
flourished, probably under the
influence of great teachers such
as Charles Binns. Also,
technological changes which
enabled single potters to
maintain kilns at home
increased the viability of lone
studio potters. Commercial
potteries turned more to
industrial art wares, and less to
handmade or decorated pieces.
Only a handful of high quality
factory-produced pieces
appeared after World War II, at
places like Rookwood, and even
these were subsidized by
commercial lines which were
more profitable.

19.
Vase

Bybee Pottery, Lexington, Ky.,
ca. 1926

Buff earthenware body, oriental
baluster form with high
shoulders and narrow flared
neck; overall satin glaze of deep
purple (called "amethyst" in
Museum files), apparently
applied over a pale blue ground
glaze which shows in rubbed
areas

H. 12½"; D. 6½"

Mark: adhesive tape with *BYBEE*
in ink

Purchase 1927
J. Ackerman Coles Fund
27.283

Bybee was a locally-known
pottery in Kentucky at which all
work was done by hand and
some unusual glazes were
produced, as this striking
"amethyst" glaze demonstrates.
The very low cost of this vase,
$1.50, contrasts dramatically with
original purchase prices of
pieces by the more celebrated
studio potters and producers in
New York and Ohio.
Correspondence with Bybee's
president, T.B. McCoun,
indicates that all of their pieces
were produced on a kick wheel
by traditionally trained country
potters or "turners" (Newark
Museum archives). Unlike most
American art pottery, Bybee
comes closer to being folk
pottery, rather than academic or
self-conscious art pottery.

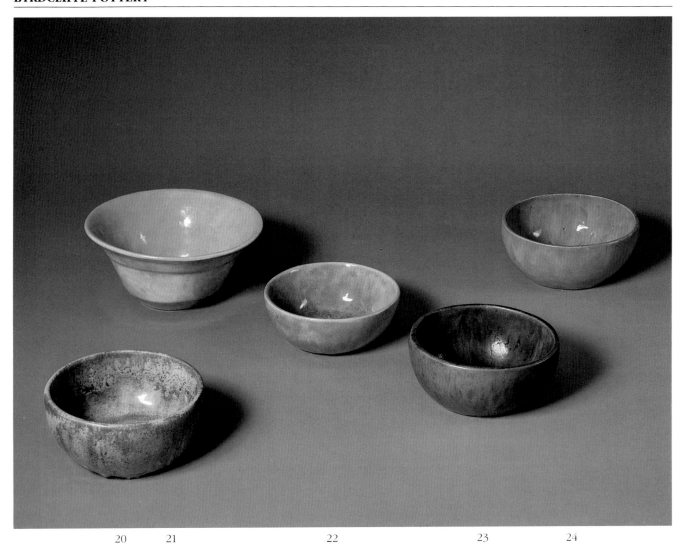

20 21 22 23 24

20.
Bowl

Byrdcliffe Pottery,
Woodstock, N.Y.,
1917-18

Buff earthenware body, plain
deep bowl form; overall glaze of
slightly mottled volcanic tan and
brown with traces of purple and
blue

H. 2¾″; D. 5⅝″

Marks: impressed pottery
insignium in form of a pair of
folded wings; partial rectangular
paper label stamped
Penman/Hardenburgh

Purchase 1918
18.650

Ralph Radcliffe Whitehead
founded the Byrdcliffe Pottery in
1902, combining his wife's
middle name with the last part
of his own middle name. His co-
founders in this enterprise were
Edith Penman and Elizabeth
Rutgers Hardenburgh. All three
were Masters of the Society of
Arts and Crafts in Boston. A
summer school was run as part
of the pottery for a time, and
there was a good deal of
interchange with the ceramics
school at Alfred. Misses Penman
and Hardenburgh were
apparently the businesswomen
for the pottery, as it is their
names that appear on the labels
on the Museum's pieces. No
wheel-throwing was done in
Byrdcliffe's studio; the forms
were hand-built, and the glaze
colors were the all-important
factor (Evans 1974, 38-39). The
significance of glaze cannot be
overemphasized in art pottery,
since it was often the most
difficult aspect of the work to
control.

21.
Bowl

Byrdcliffe Pottery,
Woodstock, N.Y.,
1917-18

Buff earthenware body, flared
deep bowl form; exterior glaze
of gray-tan crackle with interior
having light blue-green fine
crackle

H. 3½″; D. 7⅝″

Marks: impressed mark, as
above, partly obscured by glaze;
paper label stamped
Penman/Hardenburgh
with price *$5.00*

Purchase 1918
18.653

22.
Bowl

Byrdcliffe Pottery,
Woodstock, N.Y.,
1917-18

Buff earthenware body, plain
deep bowl form; overall glaze of
lavender-blue with tan mottling

H. .2¼″; D. 5½″

Marks: impressed mark, as
above; partial paper label
stamped
Penman/Hardenburgh with
price *$3.00*

Purchase 1918
18.654

23.
Bowl

Byrdcliffe Pottery,
Woodstock, N.Y.,
1917-18

Buff earthenware body, plain
deep bowl form; overall flambé
mat glaze of deep blue-green
(some glossy areas on exterior,
apparently a translucent green
glaze applied over the mat deep
blue-green, the former largely
burned off)

H. 2⅝″; D. 5⅝″

Mark: impressed mark as above

Purchase 1918
18.651

All of the Byrdcliffe pieces in
Newark's collection ranged in
price from $3 to $5.

24.
Bowl

Byrdcliffe Pottery,
Woodstock, N.Y.,
1917-18

Buff earthenware body, plain
deep bowl form; overall glaze of
bright sky blue dripping over a
pale blue-green (violet cast
overall)

H. 2¾″; D. 6″

Marks: impressed mark as above;
paper label stamped
Penman/Hardenburgh with
price *$5.00*

Purchase 1918
18.652

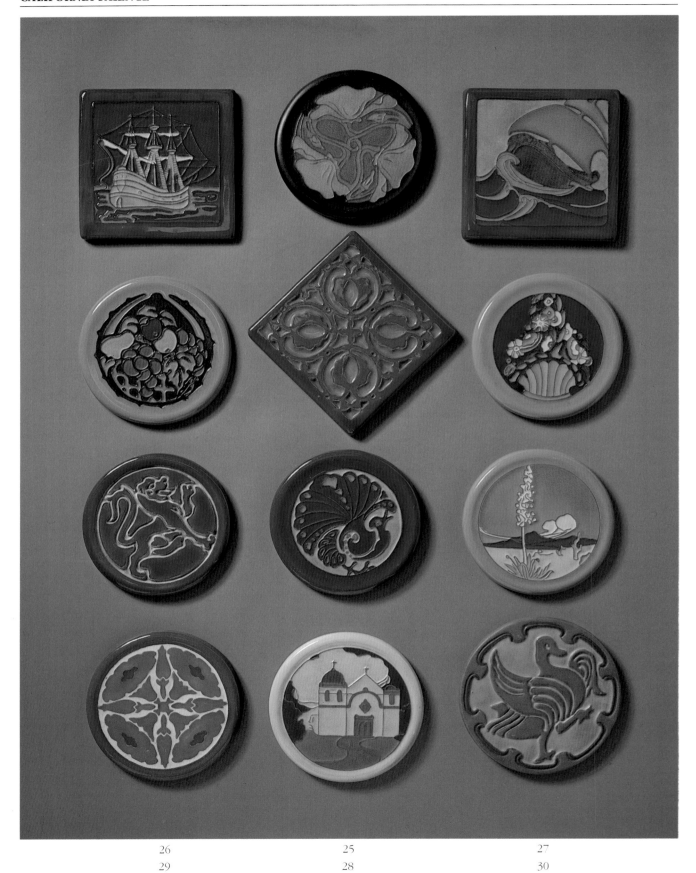

<table>
<tr><td>26</td><td>25</td><td>27</td></tr>
<tr><td>29</td><td>28</td><td>30</td></tr>
<tr><td>32</td><td>31</td><td>33</td></tr>
<tr><td>35</td><td>34</td><td>36</td></tr>
</table>

25.
Tile

California Faience, Berkeley, Ca., ca. 1926-27

Chauncey R. Thomas and William V. Bragdon

Red earthenware with molded design of intertwined poppies; mat black glaze at edge, flowers in mat orange-tan, grey-blue and olive

D. 5¼″

Marks: impressed on reverse *California/Faience*; square blue and white paper label reading *California Faience/made in/ Berkeley/California*

Purchase 1927
J. Ackerman Coles Fund
27.325

Selling for $1 each, these tiles were among the most colorful of the California Faience output. The firm was established by Thomas and Bragdon in 1916, and named as given here in 1924. It ceased regular production during the Depression.

26.
Tile

California Faience, Berkeley, Ca., ca. 1926-27

Chauncey R. Thomas and William V. Bragdon

Red earthenware with molded design of a three-masted ship; ochre, brown and turquoise glazes with lapis blue edge

5⅜″ sq.

Marks: as above, with label

Purchase 1927
J. Ackerman Coles Fund
27.311

27.
Tile

California Faience, Berkeley, Ca., ca. 1926-27

Chauncey R. Thomas and William V. Bragdon

Red earthenware with molded design of a Viking ship; dark brown, ochre and light blue glazes with turquoise highlights

5⅜″ sq.

Marks: as above, with label

Purchase 1927
J. Ackerman Coles Fund
27.312

28.
Tile

California Faience, Berkeley, Ca., ca. 1926-27

Chauncey R. Thomas and William V. Bragdon

Red earthenware with molded design of a Persian-type abstract pattern with four "petals"; turquoise and lapis blue glazes

5⅜″ sq.

Marks: as above, with label

Purchase 1927
J. Ackerman Coles Fund
27.313

29.
Tile

California Faience, Berkeley, Ca., ca. 1926-27

Chauncey R. Thomas and William V. Bragdon

Red earthenware with molded design of a hanging basket of fruit; mat glazes of deep blue, ochre, olive and red-brown

D. 5⅜″

Marks: as above, with label

Purchase 1927
J. Ackerman Coles Fund
27.320

30.
Tile

California Faience, Berkeley, Ca., ca. 1926-27

Chauncey R. Thomas and William V. Bragdon

Red earthenware with molded design of a basket of flowers; mat dark blue ground with glossy glazes in pale green, turquoise, mustard, lilac-pink and dark green with glossy turquoise edge

D. 5¼″

Marks: as above, with label

Purchase 1927
J. Ackerman Coles Fund
27.321

31.
Tile

California Faience, Berkeley, Ca., ca. 1926-27

Chauncey R. Thomas and William V. Bragdon

Red earthenware with molded design of peacock; mat glazes of ochre, lapis, brown and turquoise with glossy lapis blue edge

D. 5¼″

Marks: as above, with label

Purchase 1927
J. Ackerman Coles Fund
27.316

32.
Tile

California Faience, Berkeley, Ca., ca. 1926-27

Chauncey R. Thomas and William V. Bragdon

Red earthenware with molded design of rampant lion; lapis blue and ochre glazes

D. 5¼″

Marks: as above, with label

Purchase 1927
J. Ackerman Coles Fund
27.317

33.
Tile

California Faience, Berkeley, Ca., ca. 1926-27

Chauncey R. Thomas and William V. Bragdon

Red earthenware with molded design of desert landscape with yucca plant; sky blue, ochre, pale green and deep blue with turquoise edge

D. 5¼″

Marks: as above, with label

Purchase 1927
J. Ackerman Coles Fund
27.318

34.
Tile

California Faience, Berkeley, Ca., ca. 1926-27

Chauncey R. Thomas and William V. Bragdon

Red earthenware with molded design of a mission; glossy ochre glaze with mat gray-blue, green, brown, white, dark blue and dark olive glazes and glossy mustard edge

D. 5⅜"

Marks: as above, with label

Purchase 1927
J. Ackerman Coles Fund
27.319

35.
Tile

California Faience, Berkeley, Ca., ca. 1926-27

Chauncey R. Thomas and William V. Bragdon

Red earthenware with molded Persian-type abstract motif; turquoise with white glazes with dark blue highlights

D. 5⅜"

Marks: as above, with label

Purchase 1927
J. Ackerman Coles Fund
27.314

36.
Tile

California Faience, Berkeley, Ca., ca. 1926-27

Chauncey R. Thomas and William V. Bragdon

Red earthenware with molded design of duck flapping wings; mat gray-blue and ochre glazes

D. 5⅝"

Marks: as above, with label

Purchase 1927
J. Ackerman Coles Fund
27.315

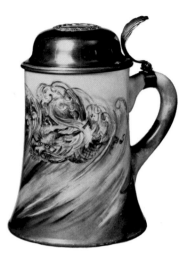

37.
Tankard

Ceramic Art Company,
Trenton, N.J.,
ca. 1895

Decorated by
Clara Chipman Newton,
Cincinnati, Ohio

Porcelain body; overglaze enamels in green, tan and gold; silver mounts

H. 6⅞"; O.W. 5"

Marks: printed *CAC* palette mark in lavender; painted signature *Clara Chipman Newton/ Cincinnati* in red enamel

Gift of
Dr. and Mrs. Paul Rylander in memory of Charles Tranter 1982
82.123

Clara Newton was not only a decorator at the Rookwood Pottery, but the first secretary of the firm. Japanese influence is evident in this swirling sea dragon. The appearance of her artistry on this piece of New Jersey belleek porcelain points up the similarity in outlook of the early art potteries and the art porcelain producers.

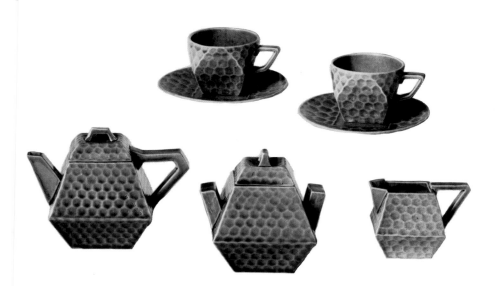

38.
Tea Set (teapot, creamer, sugar, two cups and saucers)

Chelsea Keramic Art Works, Chelsea, Ma., 1875-80

James Robertson and Sons, designers

White earthenware bodies of double, truncated pyramidal form with overall hexagonal hammering; overall blue-green slightly mottled glaze

Teapot: H. 4¾"; O.W. 6"

Marks: impressed *CKAW* in diamond-form cipher on every piece but saucers; saucers have complete three-line impressed title *Chelsea Keramic/Art Works/Robertson & Sons*

Purchase 1983
Louis Bamberger Bequest Fund
83.66

James Robertson established the Chelsea Keramic studio in 1872 with his sons, Alexander and Hugh. The output of this firm was influenced by French ceramics as well as by classical oriental porcelains. This remarkable tea set shows a design far ahead of its time, yet entirely appropriate to the orientalizing taste of the early art pottery aesthetic. The honeycombed surface texture and the pyramidal forms are conscious breaks with traditional European ceramic shapes. Such pottery was still very much part of the Victorian world, but was a precursor of more drastic changes in ceramic design.

39.
Vase

Clewell Metal Art, Canton, Ohio, ca. 1926

Copper-clad ceramic body; overall verdigris patination

H. 4¾"; D. 3⅛"

Mark: scratched *CLEWELL*

Purchase 1927
27.242

Charles Walter Clewell began his career as a metalworker in 1906. He deposited metal finishes on ceramic pieces, and then oxidized the metal to achieve ancient-looking surfaces. Vehemently opposed to being considered a potter, he went so far as to insist that his wares not be listed as pottery, but as bronzes (Newark Museum archives). This vase was sold to the Museum from the Society of Arts and Crafts in Boston. A small wedge had been cut from the bottom to show the construction, probably for showroom display purposes. The modest purchase price of $3 reflects this use. Clewell, who always worked alone, lived until 1965.

40.
Vase

Clewell Metal Art, Canton, Ohio,
ca. 1926

Copper-clad ceramic body;
overall verdigris patination

H. 11⅝"; D. 5½"

Mark: scratched *CLEWELL*

Purchase 1926
26.11

The original purchase price
from the Society of Arts and
Crafts in Boston was $18.90.

41.
Vase

Clifton Art Pottery, Newark, N.J.,
1906

White porcelaneous
earthenware, squat globular
form with raised flared neck;
metallic gray-green crystal patina
and deep jade glaze with yellow-
green toward top; overall vertical
striations with glossy streaking
in brown and blue at base

H. 7½"; D. 6½"

Marks: incised *Clifton/1906*;
form number *150*

Purchase 1911
11.483

The original purchase price of
this piece was $8.

42.
Vase

Clifton Art Pottery, Newark, N.J.,
1906

White porcelaneous
earthenware, bottle form; gray-
green crystalline glaze with
dripping extending from neck
into body

H. 13"; D. 7½"

Marks: incised *Clifton/1906*;
incised *CPL* cipher; form
number *175*; paper price tag
$15.00

Purchase 1911
11.479

The Clifton Pottery was founded
in 1905 by Fred Tschirner and
William A. Long (formerly of the
Lonhuda Pottery). Two basic
lines of pottery were developed:
classical and oriental forms in a
fine white earthenware, colored
in shades of yellow or green
"crystal patina" glazes, and an
unglazed line of "Indian ware"
pieces modeled after prehistoric
Native American forms. The fine
subtle glazes of the crystal patina
wares and the unique Indian
wares (imitated, but not suc-
cessfully) gave Clifton a wide
reputation during its short ca-
reer. The Newark Museum
bought its first pieces for the
1910-11 exhibition, *Modern
American Pottery*, and has since
added many examples. Long left
for the Weller pottery in 1909,
and the art pottery lines were
discontinued in 1911.

43.
Vase

Clifton Art Pottery, Newark, N.J.,
1907

White porcelaneous
earthenware body, globular form
with high trumpet neck; overall
mottled medium jade green
satin glaze with patches of dark
green crystallizing

H. 10"; D. 6½"

Marks: incised *Clifton/1907*; *CPL*
cipher; form number *174*

Bequest of
Mrs. John Cotton Dana 1931
31.768

44.
Vase

Clifton Art Pottery, Newark, N.J.,
1907

White porcelaneous
earthenware, baluster form with
trumpet neck; metallic yellow-
green crystal patina glaze with
darker striations from neck into
body

H. 12½"; D. 5¼"

Marks: incised *Clifton/1907*; *CPL*
cipher; form number *173*

Purchase 1911
11.480

The Museum paid half of the $15
retail price for this vase.

45.
Vase

Clifton Art Pottery, Newark, N.J.,
1905

White porcelaneous
earthenware, flattened oval form
with raised neck (similar to
"olla" form in Indian ware line);
overall mat light blue-green
glaze

H. 5"; D. 8¼"

Marks: incised *Clifton/1905*;
form number *160*

Purchase 1971
Thomas L. Raymond Bequest
Fund
71.71

46.
Vase

Clifton Art Pottery, Newark, N.J.,
1905

White porcelaneous
earthenware body, baluster form
with raised flared neck; overall
yellow-green crystal patina glaze

H. 9⅛"; D. 4"

Marks: incised *Clifton/1905*;
form number *156*

Purchase 1929
29.1001

This vase was originally bought
by John Cotton Dana from the
1911 exhibit, and was
subsequently purchased from
his estate by the Museum.

47.
Vase

Clifton Art Pottery, Newark, N.J.,
1906

White porcelaneous
earthenware, globular form with
high trumpet neck; overall deep
jade green mat glaze

H. 10¼"; D. 6½"

Marks: incised *Clifton/1906*;
form number *184*

Purchase 1911
11.481

The original retail cost was $6.

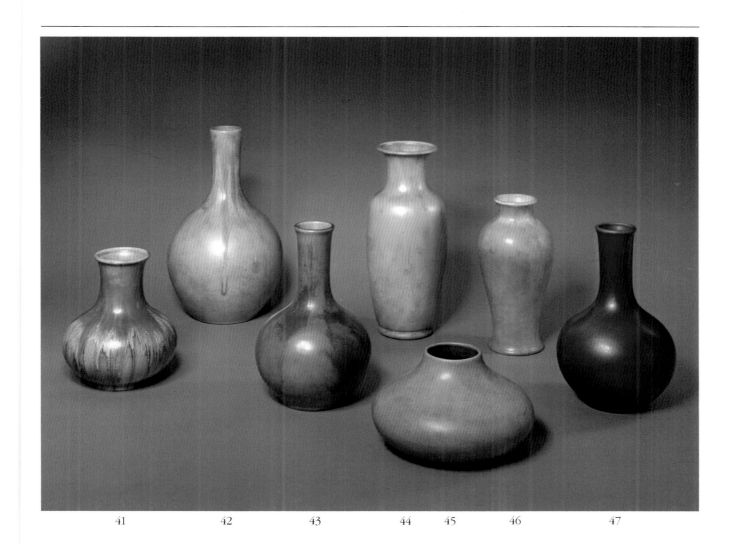

41 42 43 44 45 46 47

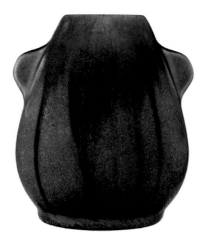
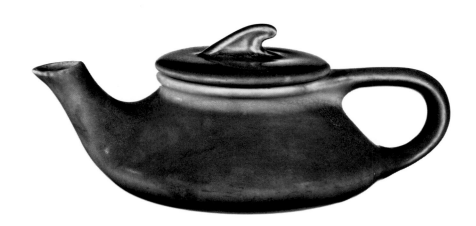

48.
Miniature Vase

Clifton Art Pottery, Newark, N.J., 1906

White porcelaneous earthenware, ovoid form with small mouth and two semicircular tab handles; overall striated yellow-green crystal patina glaze

H. 4⅜"; D. 3½"

Marks: incised *Clifton/1906*; *CPL* cipher; form number *185*; paper price tag *$2.50*

Purchase 1911
11.482

49.
Teapot

Clifton Art Pottery, Newark, N.J., 1905-11

White porcelaneous earthenware, flattened, truncated conical form with short spout, D-shaped handle and flat, deeply flanged lid with fin-shaped finial; overall deep leaf green mat glaze

H. 3¾"; O.W. 9¼"

Marks: form numbers *270* and *270•30*

Gift of
Mrs. Constance B. Benson 1977
77.156

Although this marvelous teapot is not marked, the form and style of numbers, as well as the body and glaze, leave no doubt that this is a piece by Clifton. The pair of teapots below have nearly identical numbering.

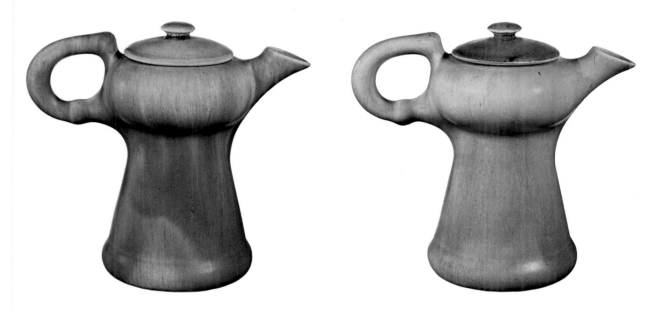

50. A, B
Teapots (pair)

Clifton Art Pottery, Newark, N.J.,
ca. 1910

White porcelaneous
earthenware, flattened ball form
on truncated conical bases with
short flared spouts, applied oval
handles and deeply flanged
domed lids with button finials;
overall yellow-green crystal
patina glaze

Each H. 6½"; W. 7"

Marks: blue-green printed mark
Clifton/Pottery/Newark.N.J.
within a *C*; form numbers *272*
and *272•36*

Purchase 1978
Sophronia Anderson Bequest
Fund
78.367-368

Note that these teapots and the
one preceding are assigned
form numbers in the 200 range,
which Evans has noted were
given to pieces in the Indian
ware line (1974, 62). The
unusual forms, while adapted to
modern use, may have been
derived from actual Indian
forms, however loosely.

51.
Miniature Olla

Clifton Art Pottery, Newark, N.J.,
ca. 1906-11

Buff unglazed earthenware;
designs applied in black and red
banding

H. 2¼"; D. 4½"

Marks: incised *Clifton*; form
number *105*

Gift of
the Lucy B. Cooley Estate 1916
16.152

The popularity of Indian artifacts
during the Arts and Crafts era
led the Clifton Pottery to
introduce an extensive line of
shapes derived from
archeological forms and
decoration. The Museum did not
initially buy any Indian ware
from Clifton, probably thinking
it too ethnological to relate to
the rest of the art pottery in the
1910-11 exhibition. The
Museum's collection of actual
Native American pieces was also
being formed during this period,
which may have spurred interest
in acquiring Clifton Indian ware
from the Cooley estate in 1916.

52.
Water Vessel

Clifton Art Pottery, Newark, N.J.,
1906-11

Unglazed red earthenware,
flattened globe form from which
rise two hollow tubes meeting at
raised neck at top; black
geometric decoration

H. 8⅝"; D. 6½"

Marks: impressed *Clifton*;
incised *Arkansas*; Indian ware
cipher; form number *244*

Gift of
the Lucy B. Cooley Estate 1916
16.157

53.
Mug

Clifton Art Pottery, Newark, N.J.,
1906-11

Unglazed orange earthenware
with applied C-form handle;
black glazed interior with
geometric designs in black on
exterior

H. 3½"; O.W. 5¾"

Marks: impressed *Little
Colorado, Arizona*; form
number *215*

Purchase 1973
Harry E. Sautter Endowment
Fund
73.118

54.
Vase

Clifton Art Pottery, Newark, N.J.,
1906-11

Unglazed red earthenware,
flattened globe form with tall
cylindrical neck; pinwheel and
geometric decoration in black
and tan

H. 12"; D. 10"

Marks: incised *Clifton*;
impressed *Mississippi*; Indian
ware cipher; form number *227*

Purchase 1978
Sophronia Anderson Bequest
Fund
78.210

55.
Pitcher

Clifton Art Pottery, Newark, N.J.,
1906-11

Unglazed buff earthenware with
C-form handle and flared lip on
squat rounded body; decorated
in dark red and black and tan-
grey

H. 5"; W. 9"

Marks: incised *Little Colorado/
Arizona*; Indian ware cipher;
form number *275*

Gift of
the Lucy B. Cooley Estate 1916
16.158

56.
Olla

Clifton Art Pottery, Newark, N.J.,
1906-11

Unglazed orange-red
earthenware, flattened oval form
with raised neck; geometric
decoration in black, buff and
white

H. 5⅛"; D. 8"

Marks: impressed *Clifton*;
incised *FourMile Ruin/Arizona*;
Indian ware cipher; form
number *160*

Gift of
Mr. and Mrs. George Hay 1932
32.353

Note that while this form was
developed as a crystal patina
body in 1905, the Indian ware
line was not brought out until
1906. Thus, it seems that the
inspiration for using Native
American forms preceded the
actual reproduction of Indian
pieces.

57.
Olla

Clifton Art Pottery, Newark, N.J.,
1906-11

Unglazed red earthenware,
flattened reel form with wide
cylindrical neck; geometric
decoration in tan, red and black

H. 8¼"; D. 14"

Marks: *Clifton* impressed twice;
impressed *Pueblo Viejo/Upper-
Gila-Valley/Ariz.*; form number
190

Purchase 1978
Franklin Conklin, Jr. Memorial
Fund
78.121

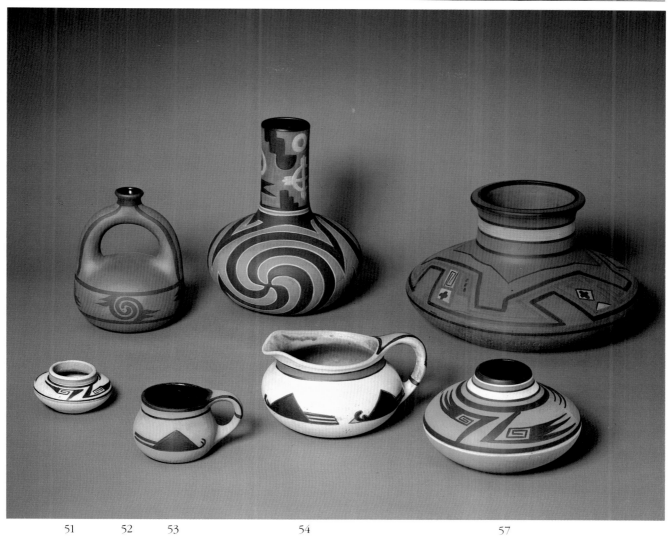

51 52 53 54 57
 55 56

58.
Bowl

Clifton Art Pottery, Newark, N.J.,
1906-11

Unglazed red earthenware,
shallow bowl form; exterior grid
in black with a smeared black
interior

H. 2½″; D. 9″

Unmarked

Gift of
the Lucy B. Cooley Estate 1916
16.155

59.
Vase

Clifton Art Pottery, Newark, N.J.,
1906-11

Unglazed red earthenware,
flattened ball form with raised
cylindrical neck; decorated with
geometric designs in red, buff
and black

H. 4¾″; D. 7¼″

Marks: impressed *Clifton*;
impressed *Homolobi, Arizona*
on side; Indian ware cipher

Gift of
the Lucy B. Cooley Estate 1916
16.156

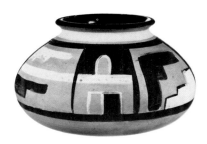

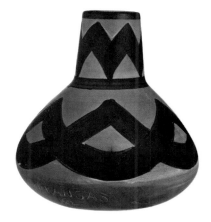

60.
Bowl

Clifton Art Pottery, Newark, N.J., 1906-11

Unglazed purplish-red earthenware; ovoid form with wide mouth; geometric designs in red with black and white banding

H. 6″; D. 8″

Marks: impressed *Clifton/Four Mile Ruin/Arizona*; Indian ware cipher; form number *248*

Gift of
the Lucy B. Cooley Estate 1916
16.153

61.
Vase

Clifton Art Pottery, Newark, N.J., ca. 1906-11

Unglazed red earthenware, squat ovoid form with raised neck; decorated with geometric black and white banding

H. 3½″; D. 5½″

Marks: impressed *Clifton/SHUNGOPOVI/Arizona*; Indian ware cipher; form number *279*

Gift of
the Lucy B. Cooley Estate 1916
16.154

62.
Vase

Clifton Art Pottery, Newark, N.J. 1906-11

Unglazed red earthenware, gourd form with tapered neck; decoration in black of interlaced scalloped lines

H. 6″; D. 5½″

Marks: incised *Arkansas*; Indian ware cipher; form number *238*

Purchase 1976
Mathilde Oestrich Bequest Fund
76.233

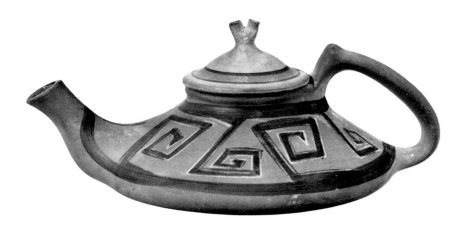

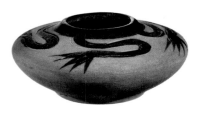

63.
Teapot

Clifton Art Pottery, Newark, N.J.
1906-11

Unglazed red earthenware,
flattened truncated conical form
with short curved spout and
applied Q-shaped handle; black
geometric decoration

H. 3¼"; O.W. 8½"

Marks: impressed *Clifton*; form
number *275*

Purchase 1976
Mathilde Oestrich Bequest Fund
76.234

64.
Miniature Vessel

Clifton Art Pottery, Newark, N.J.
1906-11

Unglazed red earthenware,
flattened reel form with neck;
decorated with black swirling
forms

H. 1⅝"; D. 4"

Marks: incised *Florida*; form
number *184*

Purchase 1973
Harry E. Sautter Endowment
Fund
73.119

65.
Miniature Vase

Clifton Art Pottery, Newark, N.J.
1906-11

Unglazed red-brown
earthenware, flattened globe
form with raised flared neck;
black geometric decoration

H. 2⅝″; D. 3″

Marks: impressed *Clifton* and
Four Mile Ruin Arizona; Indian
ware cipher

Purchase 1973
Frederick P. Field Bequest Fund
73.57

66.
Vessel (Vase)

Clifton Art Pottery, Newark, N.J.
1906-11

Unglazed dark red-brown
earthenware, flattened globe
form with cylindrical neck; black
and buff geometric decoration

H. 6½″; D. 8¾″

Marks: incised *Clifton* and
Homolobi; Indian ware cipher;
form number *234*

Purchase 1978
Franklin Conklin, Jr. Memorial
Fund
78.122

67.
Vase

Cowan Pottery, Rocky River, Ohio
ca. 1920

White porcelaneous body,
classical squat form; overall
lightly striated medium red-
brown glaze

H. 5⅝"; D. 6⅛"

Marks: impressed *COWAN*;
impressed pottery insignium
COWAN over stylized *R.G.*

Purchase 1983
Louis Bamberger Bequest Fund
83.59

In 1920 R. Guy Cowan moved his
small redware art pottery firm
from Cleveland to Rocky River,
Ohio. A new porcelain-like body
was adopted and modern art
wares were produced, often in
the Art Deco style. This simple
vase is typical of the classically-
and orientally-inspired objects
which were sold all over the
United States during the 1920s.

68.
Vase

Cowan Pottery, Rocky River, Ohio
ca. 1920-30

White porcelaneous body
molded in sculptural form of a
lotus blossom vase with an
oriental bird; overall brilliant
turquoise blue ("Egyptian blue")
crackled glaze

H. 11⅜"; W. 7¾"

Marks: impressed pottery
insignium of *COWAN* over
stylized *R.G.*

Purchase 1983
Louis Bamberger Bequest Fund
83.60

The lure of oriental design
continued to inspire art potters
well into the twentieth century,
as demonstrated by this
splendid vase, modeled loosely
on Far Eastern forms. The glaze,
a speciality of the pottery, was
known as "Egyptian blue," an
apt name (Kovel 1974, 21).
Leon Volkmar used similar
glazes in the 1920s, as did
Rookwood.

69.
Vase

Russell G. Crook,
South Lincoln, Ma.
ca. 1913-14

Gray-tan stoneware body with
wide mouth and molded lip,
tapered at bottom; painted
stylized decoration of flying
dinosaurs (dragons?) in black on
a cobalt brushed glaze ground
with volcanic mat black glazed
interior

H. 4⅜"; D. 4⅜"

Unmarked

Purchase 1914
14.925

The fact that this piece was
acquired at the Society of Arts
and Crafts in Boston indicates
that Russell Crook was a potter
of some local renown and
considered worthy of display in
the Society's shop. Fascinating
glaze technique and fine work
are typical of the many now-
unknown works produced by
studio potters in the Arts and
Crafts era.

70.
Bowl

Ellen W. Cushing, Boston, Ma.
ca. 1925

Buff earthenware, shallow
conical form on raised foot;
exterior overall bubbled mauve-
brown glaze, interior slip
painted with oriental banding
and flowers in mauve-gray on a
cream ground glaze

H. 3½"; D. 7⅜"

Marks: impressed, but obscured
by plain paper label with price
$9.00

Purchase 1926
26.12

Ellen Cushing is a little-known
potter, but her work was good
enough to have her listed as a
Master Potter by the Society of
Arts and Crafts in Boston, where
the Museum bought this piece.
Other Master Potters included
William Hill Fulper II, Adelaide
Robineau and Charles Binns.

71.
Saucer

Dedham Pottery, Dedham, Ma.
ca. 1895

Designed by
Joseph Lindon Smith

Buff earthenware; heavy white
crackled glaze overall, painted
with blue border design of
rabbits and leaves

D. 6¼″

Mark: impressed cipher of
frontal rabbit in circle

Gift of the
Newark Technical School 1926
26.2757

After the demise of the
Chelsea Keramic Art Works,
Hugh Robertson established the
Dedham Pottery and operated it
until his death in 1908. His most
popular products were the
crackleware dinner services,
made in a variety of patterns and
several colors. The classic
Dedham crackle is blue and
white with rabbits, designed by
the director of the Boston
Museum of Fine Arts in 1891
and intended to represent
rabbits and brussels sprouts
(Clark 1979, 129).

72.
Vase

Dedham Pottery, Dedham, Ma.
ca. 1890-1900

Designed by Hugh Robertson

White stoneware body; brown
volcanic glaze over mottled
olive-green, orange peel glaze

H. 7¾″; D. 4¾″

Marks: incised *DEDHAM Pottery*
with ink stock number; incised
cipher *DW* or *BW*

Purchase 1983
Louis Bamberger Bequest Fund
83.56

Continuing the tradition of the
defunct Chelsea Keramic studio,
Hugh Robertson produced a
line of volcanic wares, with
heavily dripping monochromatic
glazes inspired by ancient
oriental porcelains and pottery.
By this date the orientalized
enameled art wares had begun
to give way to simpler
expressions of oriental taste
achieved through classic forms
and technically difficult glazes.
Dedham was especially known
for recreating the elusive
Dragon's Blood red glaze long
lost to potters.

73.
Vase

Deerfield Pottery, Deerfield, Ma.
ca. 1916-17

Executed by Wallace Adams

Red earthenware body, globular
form with raised neck; overall
dark green glaze

H. 4⅜"; D. 4½"

Mark: incised *DP/A*

Purchase 1917
17.896

74.
Bowl

Deerfield Pottery, Deerfield, Ma.
ca. 1916-17

Executed by Wallace Adams

Red earthenware, hemispherical
form; overall mat dark brown
glaze

H. 2¼"; D. 4½"

Mark: incised *DP/A*

Purchase 1917
17.897

According to Museum files,
Mrs. M. S. Hyde of Deerfield was
the vendor for both of these
pieces by an otherwise unknown
pottery. Perhaps Adams was a
small studio potter working
alone.

75.
Vase

Durant Kilns,
Bedford Village, N.Y.
ca. 1925-26

Executed by Leon Volkmar

Coarse buff earthenware body,
tall baluster form with flared foot
and neck; overall crackled
turquoise glaze, with exception
of unglazed foot

H. 12¼"; D. 7½"

Mark: incised *DURANT*

Purchase 1926
26.15

The original purchase price,
from Arden Studios in New York,
was $187.50.

76.
Bowl

Durant Kilns,
Bedford Village, N.Y.
1924

Executed by Leon Volkmar

Coarse buff earthenware body,
flared flower form; interior with
medium turquoise crackle,
exterior with deep eggplant
purple mottled glaze

H. 4⅝"; D. 9¼"

Marks: incised *DURANT/1924*
and *V*

Purchase 1926
26.13

Although the $40 purchase price
of this piece was high, the
extreme cost of the larger
Durant piece indicates Leon
Volkmar's prestige in the 1920s,
as well as the time-consuming
process of achieving a subtle
Egyptian faience glaze. Leon left
his father's New Jersey pottery to
join Jean Rice and form the
Durant Kilns in 1910-11, at
approximately the time the
Volkmar Kilns were lending
pieces to the Newark Museum.
Mrs. Rice had been a student of
Leon's in New Jersey. The Arden
Studios in New York, sole agent
for Durant and source for both
of the Museum pieces, sold the
kiln's goods until 1926. Newark's
two pieces are typical of Durant's
simple, classic or oriental forms
and striking glazes. Mrs. Rice
died in 1919, and the Durant
Kilns name died in 1930.

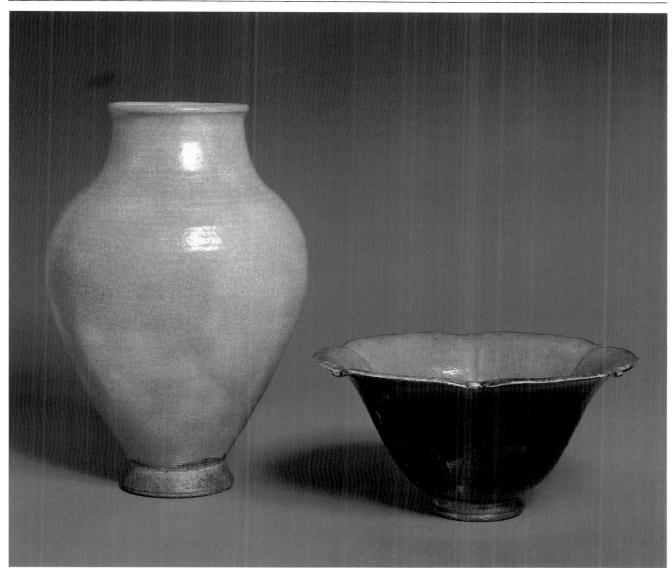

75 76

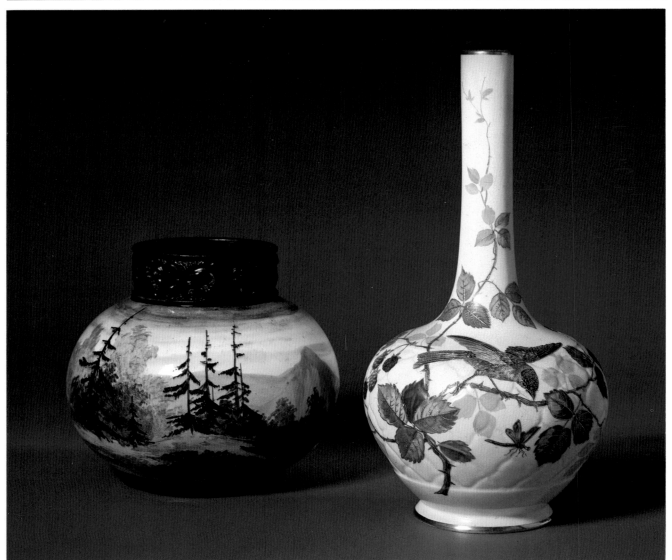

77 78

77.

Vase

Faience Manufacturing Company,
Brooklyn, N.Y.
ca. 1880-84

Buff earthenware with raised
molded collar and flattened
globe form base; underglaze
painted scene of mountain
landscape and log building

H. 7½"; D. 8½"

Mark: impressed *FMCo*

Purchase 1983
Louis Bamberger Bequest Fund
83.52

Concurrent with the early efforts
in Ohio and New Jersey, Faience
Manufacturing Company was
producing art wares in Brooklyn
in the 1880s, until it ceased
production in 1889. This piece, a
conscious effort to transform a
piece of pottery into an art
object, represents an experiment
in artistic decoration that recalls
the contemporary landscapes of
Moran and Bierstadt. Regardless
of the success of the decoration,
this vase stands as an important
link between high Victorian taste
and that of the aesthetic
reformers. Edward Lycett,
premier ceramic decorator,
radically transformed the
Faience Manufacturing
Company's output after 1884.

78.

Vase

Faience Manufacturing Company,
Brooklyn, N.Y.
ca. 1884-85

Decorated by Edward Lycett (?)

White earthenware molded in
overall quilted pattern, bottle
form; overglaze painted and
gilded with polychrome foliage,
bird and insects

H. 13¼"; D. 7"

Marks: impressed *FMCo*; *FMCo*
cipher printed in green

Purchase 1983
Louis Bamberger Bequest Fund
83.64

Edward Lycett's appearance at
Faience Manufacturing Company
changed the look of the firm's
output to a highly-finished,
orientally inspired taste. Lycett
refined the clay bodies to a very
white ware, and designed as
well as executed finely detailed
and gilded decoration based on
Japanese sources. These later
pieces relate in technique
more to the art porcelains of
Trenton than to the ware of
Rookwood, although the
same aesthetic impetus drove
both Edward Lycett and
Maria Longworth Nichols.

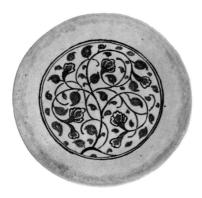

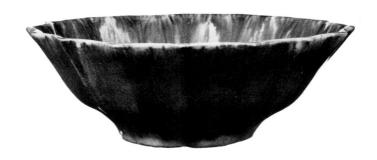

79.
Plate

George Francis Frederick,
Trenton, N.J.
ca. 1926-27

Buff earthenware plate; overall
crackled glaze shading from pale
blue at rim to cream in central
area, overpainted with Persian-
style floral vines in blue and
green

D. 7⅜"

Marks: painted blue *GFF* cipher

Purchase 1927
J. Ackerman Coles Fund
27.801

The original purchase price of
this piece was $4.50.

80.
Bowl

George Francis Frederick,
Trenton, N.J.
ca. 1926-27

Buff earthenware, fluted, flared
hemispherical form; outside
glazed medium blue, inside
glazed blue streaked over pale
green following lines of the
fluting

H. 2⅛"; D. 7¼"

Marks: incised *GFF* cipher as
above, partly obscured by paper
label with price *$8.00*.

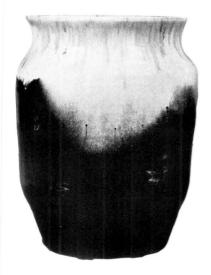

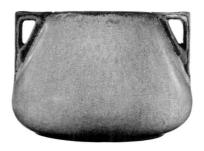

81.
Vase

George Francis Frederick,
Trenton, N.J.
ca. 1926-27

Buff earthenware, cylindrical
form pinched at rim to make
wide mouth; rim and upper
interior glazed mottled medium
blue, lower interior glazed deep
yellow, lower exterior glazed
gunmetal gray

H. 5⅜"; D. 4¼"

Marks: incised *GFF* cipher as
above; plain paper label with
price *$7.00*

Purchase 1927
J. Ackerman Coles Fund
27.803

George Frederick was the
earliest of the New Jersey studio
potters to appear in the Newark
Museum collection. Interestingly,
John Cotton Dana purchased the
three Frederick pieces at the
Woodstock Craft Shop, in Dana's
Vermont hometown. Frederick
was a pottery instructor at the
School of Industrial Arts in
Trenton.

82.
Vase

Fulper Pottery Company,
Flemington, N.J.
1913

Buff stoneware, squat broad-
based form with two angular
handles; overall mat light brown
glaze called "café au lait"

H. 4½"; D. 5⅞"

Mark: vertical rectangular ink
stamp *PRANG*

Purchase 1914
14.215

The Fulper pottery was the brain-
child of William Hill Fulper II,
whose grandfather had been a
producer of utilitarian stoneware
in Flemington since the 1860s.
After years of experimentation
with glazes and bodies, the
Vasekraft (also Vase-Kraft) line
of art ware was introduced in
1909. Fulper pottery was known
for its heavy, massive stoneware
body and its superb range of
glazes, unmatched by any other
pottery. Both mat and mirror
glazes were employed, as well as
exotic crystalline variations, and
forms were inspired by both
oriental and classical sources.
Fulper combined high quality
with high commercial success,
and although some pieces were
costly, most were within easy
reach of the aesthetically-aware
middle class family. For a short

time the Prang Art Supply
Company of New York was
allowed to sell Fulper pottery
with the Prang name stamped on
the bottom; it is assumed that
Prang supplied Fulper with
necessary chemicals for glazes.
This was the first piece of
Fulper purchased by Newark,
for *Clay Products of New Jersey*
in 1915, at a cost of $2.

83.
Vase

Fulper Pottery Company,
Flemington, N.J.
1914

Buff stoneware body, tall ovoid
shape with raised neck; overall
striated gray and blue glaze
called "Chinese blue" on label

H. 13⅛"; D. 7"

Marks: vertical rectangular ink
stamp *FULPER*; square black and
white paper *Vasekraft* label with
insignium, lower right
VASEKRAFT/FULPER 1805
encircling a potter working at a
wheel; Boston Society of Arts
and Crafts label with price *$6.00*

Purchase 1914
14.927

84.
Vase

Fulper Pottery Company,
Flemington, N.J.
1913

Buff stoneware, globular form
with short flared neck; overall
striated gray and blue glaze,
probably "Chinese blue" as
above

H. 6¾"; D. 6¾"

Mark: vertical rectangular ink
stamp *FULPER*

Purchase 1914
14.218

This vase was purchased from
the Prang Art Supply Company
in January, 1914, for $4.40.

85.
Deep Bowl

Fulper Pottery Company,
Flemington, N.J.
1914

Buff stoneware body, deep oval
form; crystalline blue and
flambé brown glazes

H. 4½"; D. 8½"

Marks: vertical rectangular ink
stamp *FULPER*; partial *Vasekraft*
label as above; Boston Society of
Arts and Crafts label with price
$2.50

Purchase 1914
14.928

86.
Vase

Fulper Pottery Company,
Flemington, N.J.
1914

Buff stoneware body, double
oviform shape; overall glaze of
crystalline "cucumber green"

H. 8⅛"; D. 5¾"

Marks: vertical rectangular ink
stamp *FULPER*; *Vasekraft* label as
above with price *$4.40*; glaze
and form name *double oviform*
in ink

Purchase 1915
15.5

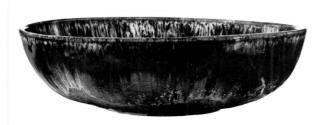

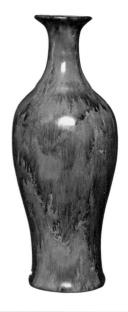

87.
Bowl

Fulper Pottery Company,
Flemington, N.J.
1914

Buff stoneware body, shallow
straight-sided bowl form; overall
glaze of mottled and striated
browns, called "brown flambé"
in Museum files, largely
concealing a "mustard matte"
glaze on underside

H. 2½"; D. 8"

Mark: vertical rectangular ink
stamp *FULPER*

Purchase 1915
15.11

The richness of the glazing on
this plain form is especially
noteworthy. The original
purchase price was $2.50.

88.
Vase (Amphora)

Fulper Pottery Company,
Flemington, N.J.
1914

Buff stoneware body, classical
baluster form with flared neck;
overall striated black and
charcoal gray glaze called "black
flambé" in Museum files

H. 8½"; D. 3¼"

Mark: vertical rectangular ink
stamp *FULPER*

Purchase 1915
15.7

The retail price of this piece was
$1.60, compared with $40 for its
identical but expensively-glazed
mate (see figure 111). The
"famille rose" glazes were
usually ten times as costly as the
regular glaze lines, and had to
be specially ordered.

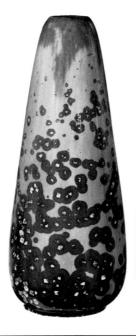

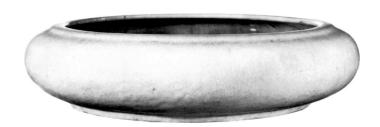

89.
Bud Vase

Fulper Pottery Company,
Flemington, N.J.
1914

Buff stoneware body, elongated
ovoid form; overall olive-gray
glaze with black crsytallizing
called "leopard skin" on label

H. 5½"; D. 2"

Marks: stamp obscured by label;
Vasekraft label as above with
price *$1.00*; glaze name and
form *Slender Ovoid* in ink

Purchase 1915
15.8

Fulper's "leopard skin" crystal
glaze was unique and hard to
achieve. The Company
considered it largely an
exhibition glaze.

90.
Flower Bowl

Fulper Pottery Company,
Flemington, N.J.
1914

Buff stoneware body, shallow
bowl form with incurved brim;
mat cream exterior glaze called
"white flambé" on label, and
crystalline turquoise interior
glaze called "turquoise crystal"
on label

H. 2⅛"; D. 8¾"

Marks: vertical rectangular ink
stamp *FULPER*; *Vasekraft* label as
above with glaze names and
price *$2.50* in ink

Purchase 1915
15.9

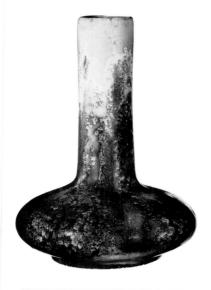

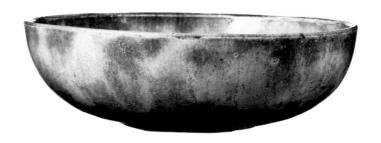

91.
Bud Vase

Fulper Pottery Company,
Flemington, N.J.
1914

Buff stoneware body, flattened
reel form with tall cylindrical
neck; overall striated gray-green
and black glaze called "green
crystalline" in Museum files

H. 5"; D. 3½"

Mark: vertical rectangular ink
stamp *FULPER*

Purchase 1915
15.10

The original purchase price
was $1.

92.
Bowl

Fulper Pottery Company,
Flemington, N.J.
1914

Buff stoneware body, shallow
straight-sided form; overall glaze
of "cucumber green"
crystallizing with darker patches

H. 2⅛"; D. 6"

Marks: vertical rectangular ink
stamp *FULPER*; partly obscured
by *Vasekraft* label as above with
price *$1.50* in ink

Purchase 1915
15.13

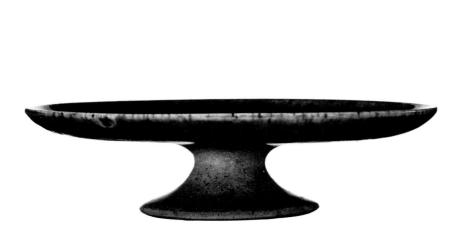

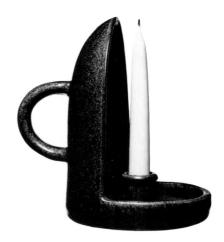

93.
Tazza (Card Receiver)

Fulper Pottery Company,
Flemington, N.J.
1914

Buff stoneware body, flattened
disk form on round footed base;
exterior mat blue glaze with
upper surface crystallized in
blue and mustard, called "blue
crystalline and brown flambé" in
Museum files

H. 2¼"; D. 8"

Mark: illegible circular ink stamp

Purchase 1915
15.14

The significance of the peculiar
mark on this piece has never
been determined.

94.
Candle Holder

Fulper Pottery Company,
Flemington, N.J.
1914

Buff stoneware body, round
plate form with short candle
socket and coved, arched
deflector with applied handle;
overall charcoal gray mat glaze
called "mission matte" on label

H. 7"; O.W. 6½"

Marks: vertical rectangular ink
stamp *FULPER*; *Vasekraft* label as
above with price *$1.50* in ink

Gift of the Pottery 1915
15.387

"Mission matte" glazed wares
were seen as especially
appropriate counterparts to the
sober, plain lines of mission
furniture by such makers as
Stickley and the Roycrofters.

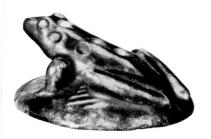

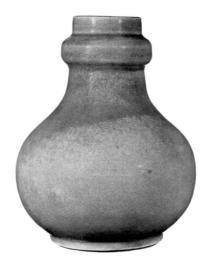

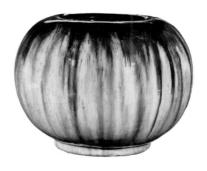

95.
Flower Frog

Fulper Pottery Company,
Flemington, N.J.
1914

Buff stoneware molded in form
of resting frog; overall
naturalistic coloring in green
and tan mat glazes

H. 2¼″; D. 4⅜″

Mark: vertical rectangular ink
stamp *FULPER*

Gift of the Pottery 1915
15.390

Fulper went so far as to suggest
the Japanese-style arrangements
that might fill its pottery. This
frog was essential for the simple,
three-flower arrangement.

96.
Vase

Fulper Pottery Company,
Flemington, N.J.
1914

Buff stoneware body with
globular base and raised neck
with bulbous mid-section;
overall mat deep pink glaze
called "rose matte" on label

H. 6⅝″; D. 5¼″

Marks: vertical rectangular ink
stamp *FULPER*; *Vasekraft* label as
above with price *$25.00* and
glaze name in ink

Gift of the Pottery 1915
15.393

97.
Rose Bowl

Fulper Pottery Company,
Flemington, N.J.
1914

Buff stoneware body, globular
form with incurved rim; overall
striated black and tan glazes,
called "black and buff flambé" in
Museum files

H. 5½″; D. 7⅜″

Mark: vertical rectangular ink
stamp *FULPER*

Gift of the Pottery 1915
15.394

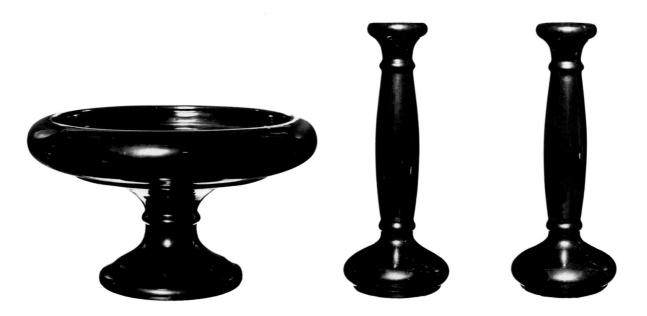

98. A, B, C
Centerpiece Bowl and Candlesticks

Fulper Pottery Company,
Flemington, N.J.
ca. 1915-20

Buff stoneware body, shallow
bowl with incurved brim on
short columnar foot with
columnar candlesticks; overall
mirror-black glaze

Bowl: H. 6¾"; D. 10¾"
Candlesticks (each):
H. 11¼"; D. 4⅜"

Marks: incised oval vertical
FULPER on each piece

Purchase 1947
Sophronia Anderson
Bequest Fund
47.36A-C

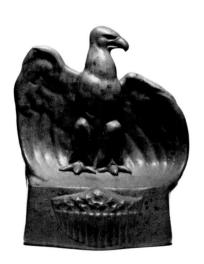

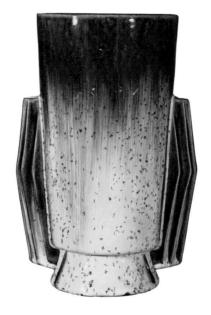

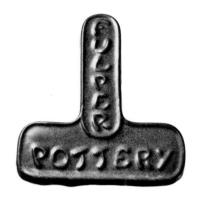

99.
Eagle Figure

Fulper Pottery Company,
Flemington, N.J.
ca. 1915

Buff stoneware body molded in
form of spread-winged eagle on
shield base; overall mat leaf
green glaze

H. 9¼"; O.W. 7¼"

Mark: vertical rectangular ink
stamp *FULPER*

Purchase 1947
Sophronia Anderson
Bequest Fund
47.38

100.
Vase

Fulper Pottery Company,
Flemington, N.J.
ca. 1930

Buff stoneware body, cylindrical
form tapered toward bottom
with molded fin-like handles at
each side; overall blue flambé
and crystalline glaze

H. 8¾"; O.W. 5⅜"

Mark: impressed horizontal
mark *FULPER* stained blue

Purchase 1980
Sophronia Anderson
Bequest Fund
80.71

The Arts and Crafts glazes suited
the new Art Deco style as they
had the earlier classical forms.
This piece is from Fulper's last
years of production.

101.
Trade Sign

Fulper Pottery Company,
Flemington, N.J.
ca. 1915

Buff stoneware body, inverted
T-form, with surface molded in
shallow relief with words
FULPER POTTERY in "artistic"
letters; overall satin copper-dust
crystalline glaze

H. 6⅛"; W. 5½"

Unmarked

Gift of the Jordan-Volpe Gallery
1980
80.258

Such a piece would have been
used in a retail outlet as an
advertising sign.

102.
Candle Holder

Fulper Pottery Company,
Flemington, N.J.
1915-20

Buff stoneware body, circular
shallow dish form with raised
candle socket at center; gray and
pink mat glazes

H. 2″; D. 5″

Mark: incised vertical oval
FULPER

Gift of Mr. Christopher Forbes
1981
81.337

103.
Flower Bowl

Fulper Pottery Company,
Flemington, N.J.
1910-15

Buff stoneware body, shallow
bowl form with incurved brim,
exterior molded with leaf forms;
interior glaze of light green
crystalline, exterior glazes of
lapis blue mat and green
crystalline

H. 2¾″; D. 11″

Mark: vertical rectangular ink
stamp *FULPER*

Gift of Mr. Christopher Forbes
1981
81.338

Interiors of flower bowls were
usually glazed in contrast to
exterior surfaces. These often
exotic glazes would have been
highlighted by the water
used in Japanese-style flower
arrangements popular during
the teens.

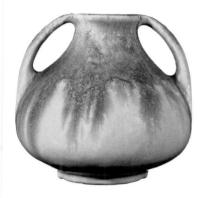

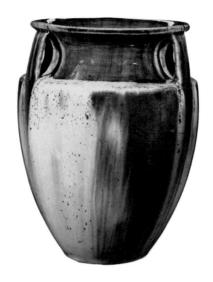

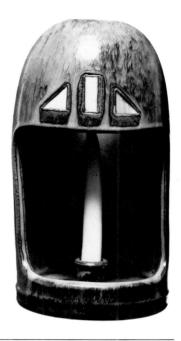

104.
Vase

Fulper Pottery Company,
Flemington, N.J.
ca. 1915-20

Buff stoneware body, broad pear
form with applied handles; deep
rose satin glaze with green
crystalline glaze

H. 6″; D. 6″

Mark: vertical oval ink stamp
FULPER

Purchase 1979
The Charles W. Engelhard
Foundation
79.194

105.
Vase

Fulper Pottery Company,
Flemington, N.J.
ca. 1915-25

Buff stoneware body, inverted
bullet form with concave
shoulder and flared rim, with
three small handles conforming
to outline of body; overall blue
flambé glaze striated with olive
green and some crystallizing

H. 6¾″; D. 4⅞″

Mark: vertical oval ink stamp
FULPER

Purchase 1982
Frederick P. Field Bequest Fund
82.104

106.
Candle Holder

Fulper Pottery Company,
Flemington, N.J.
ca. 1915

Buff stoneware body, domed
cylindrical form with rectangular
opening in front and candle
socket inside; overall gray-blue
mottled mat glaze; inset in dome
over opening are three pieces of
colored glass in lead frames

H. 10½″; D. 5⅜″

Mark: incised vertical oval mark
FULPER

Purchase 1982
Carrie B.F. Fuld Bequest Fund
82.107

One of the rarest forms in
Fulper's line, this domed
candle holder was intended for
wall mounting as well as
tabletop use.

107.
Vase

Fulper Pottery Company,
Flemington, N.J.
1914

Buff stoneware body, globular
form with raised flared neck and
applied fin-shaped handles;
overall mottled gray-pink glaze
with slight translucence called
"ashes of rose" on label

H. 12⅛"; D. 10"

Marks: raised oval vertical mark
FULPER; two Vasecraft labels as
above, one reading *taken from
an old Japanese piece* and one
with *ashes of rose* and price
$125.00 in ink

Gift of the Pottery 1915
15.407

This is perhaps the finest and
rarest piece of Fulper pottery
extant, and was certainly the
most expensive piece ever
offered in Fulper's output, itself
among the most costly of any
American pottery. The romance
surrounding this vase was
enhanced by the pride with
which Fulper advertised its
discovery of the "extinct Chinese
glazes" (Blasberg and Bohdan
1979, 15), and the difficulty of
achieving such a perfect, subtly-
shaded pink. An advertising card
for the "extinct Chinese glazes"
is now in the Newark Museum
collection, gift of the Jordan-
Volpe Gallery. Note that the
firing crack in the right handle
did not diminish the importance
of this Japanesque piece in the
company's eyes.

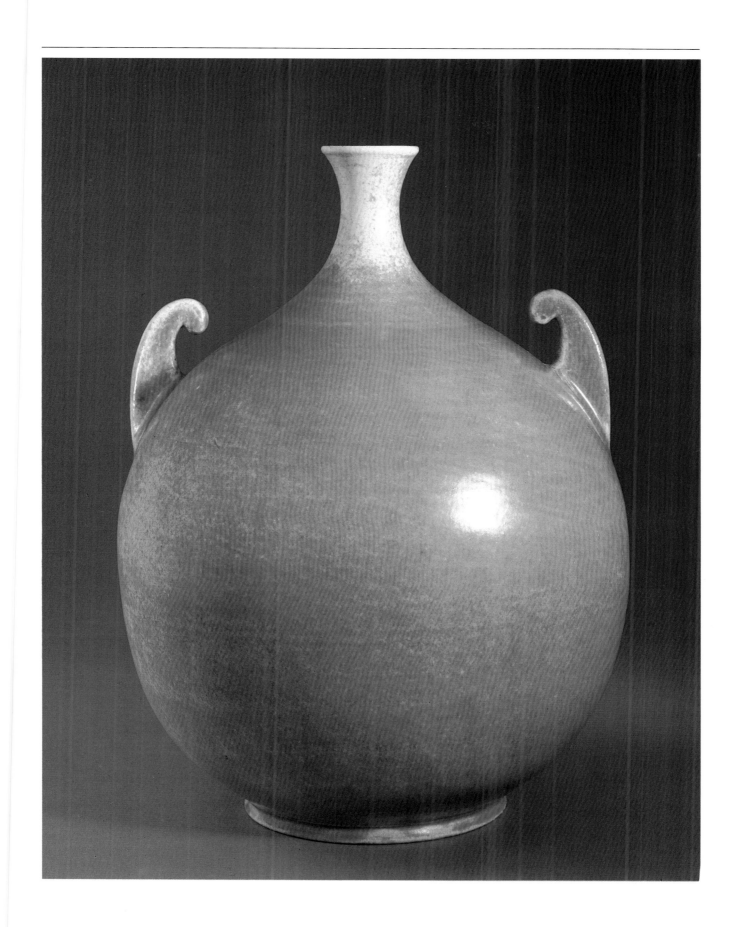

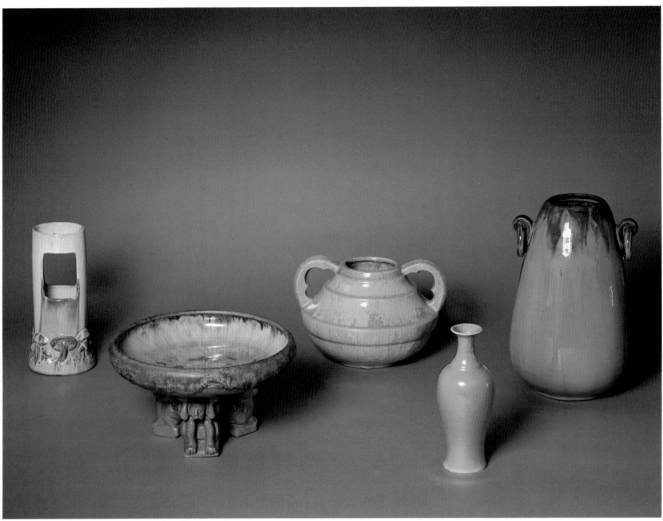

108 109 110 111 112

108.
Vase

Fulper Pottery Company,
Flemington, N.J.
ca. 1910-15

Buff stoneware body, cylindrical
form with molded design of
mushrooms around base and a
square opening front and back;
glaze shading from cream to
striated brown and rust with
purple highlights at base

H. 9¾"; D. 4¼"

Mark: vertical rectangular ink
stamp *FULPER*

Gift of the Jordan-Volpe Gallery
1982
82.108

This form was used with creative
flower arrangements requiring
two lengths of flowers.

109.
Effigy Bowl

Fulper Pottery Company,
Flemington, N.J.
1914

Buff stoneware body in form of
three crouched grotesque
figures supporting shallow bowl
with incurved brim; overall mat
and crystalline blue glazes,
called "blue of sky and blue
matte" on label

H. 6⅜"; D. 10⅝"

Marks: vertical rectangular ink
stamp *FULPER*; *Vasekraft* label as
above with price *$6.00* and glaze
names in ink

Purchase 1915
15.2

After 1915 this effigy bowl was
strengthened through the
addition of a circular disk below
the supporting figures. These
early examples are very rare.

110.
Vase

Fulper Pottery Company,
Flemington, N.J.
ca. 1920-25

Buff stoneware body, squat form
composed of horizontal convex
and concave rings with
scalloped applied handles;
overall partly volcanic light blue-
green crystalline glaze, with
traces of mustard flambé

H. 7"; O.W. 10"

Mark: oval vertical ink stamp
FULPER

Purchase 1983
The Members' Fund
83.36

This remarkable piece was
featured on an advertising
poster (Blasberg and Bohdan
1979, 88, fig. 76) designed for
Fulper by the artist Lonkay in
about 1925-30, heralding the
new Art Deco designs. The
poster is now in the Newark
Museum collection, gift of
Todd M. Volpe.

111.
Vase (Amphora)

Fulper Pottery Company,
Flemington, N.J.
1914

Buff stoneware body, classical
baluster form with flared neck;
overall deep bright pink satin
glaze called "peach bloom" on
label

H. 8½"; D. 3¼"

Marks: vertical oval ink stamp
FULPER; *Vasekraft* label as above
with price *$40.00* and glaze
name in ink

Purchase 1915
15.6

112.
Vase

Fulper Pottery Company,
Flemington, N.J.
ca. 1915-25

Buff stoneware body, elongated
ovoid form with applied ring
handles; overall blue flambé
glaze striated with olive green

H. 12¾"; D. 7⅞"

Mark: vertical oval incised mark
FULPER

Purchase 1979
The Members' Fund
79.196

113.
Jug Vase

Fulper Pottery Company,
Flemington, N.J.
ca. 1915-20

Buff stoneware body, apple form
with raised cylindrical neck and
single parabola handle at one
side; overall mat copper dust
crystalline glaze

H. 11¾"; D. 8½"

Mark: raised oval vertical mark
FULPER

Purchase 1980
Henry Puder Bequest Fund
80.56

One of Fulper's rarest glazes was
applied to this unusual form.

114.
Vase

Fulper Pottery Company,
Flemington, N.J.
1910-15

Buff stoneware body, cylindrical
form with design of cattails in
relief; overall green mat glaze
with tan highlights at edges of
design

H. 13"; D. 4¾"

Mark: vertical rectangular ink
stamp *FULPER*

Purchase 1982
Sophronia Anderson
Bequest Fund
82.106

Compare this vase with the work
of Grueby and Tiffany to see the
general fondness for vegetal
forms in art pottery.

115.
Centerpiece

Fulper Pottery Company,
Flemington, N.J.
1915-20

Buff stoneware body, molded,
round-bottomed vessel form
with concave shoulder,
supported on three scrolled legs
and conforming base; overall
hammered finish with mirror-
black glaze

H. 11½"; O.W. 12"

Mark: raised oval vertical mark
FULPER

Purchase 1978
Frederick P. Field Bequest Fund
78.118

This massive and monumental
centerpiece was introduced by
Fulper in the late teens and sold
for $25. It was offered only in
mirror-black or "mission-matte,"
and seems to have been
discontinued by 1923 (Blasberg
and Bohdan 1979, 70, fig. 64). It
was included in a circa 1920
Fulper Pottery catalogue but
omitted from the 1923 price list
insert (the Newark Museum
collection, gift of the Jordan-
Volpe Gallery). Only three
pieces of this form are now
known. Its relationship to Arts
and Crafts metal objects is clear.

116.
Vase

Fulper Pottery Company,
Flemington, N.J.
1914

Buff stoneware body, globular
form with short flared neck;
overall glaze of crystalline olive
green, called "leopard skin
crystal" on label

H. 6⅞"; D. 7"

Marks: vertical rectangular ink
stamp *FULPER*; *Vasekraft* label as
above with price *$4.40*

Purchase 1915
15.12

This is considered the finest
known example of Fulper's
"leopard skin" crystalline glaze.

117.
Vase

Fulper Pottery Company,
Flemington, N.J.
ca. 1915

Buff stoneware body, elongated
ovoid form with slightly incurved
rim; volcanic black and gray
glaze dripping heavily over
underglaze of "mustard matte"

H. 12¼; D. 8⅞"

Mark: obscured by glaze

Purchase 1979
The Charles W. Engelhard
Foundation
79.193

"Mustard matte" was a unique
glaze for Fulper and a source of
pride.

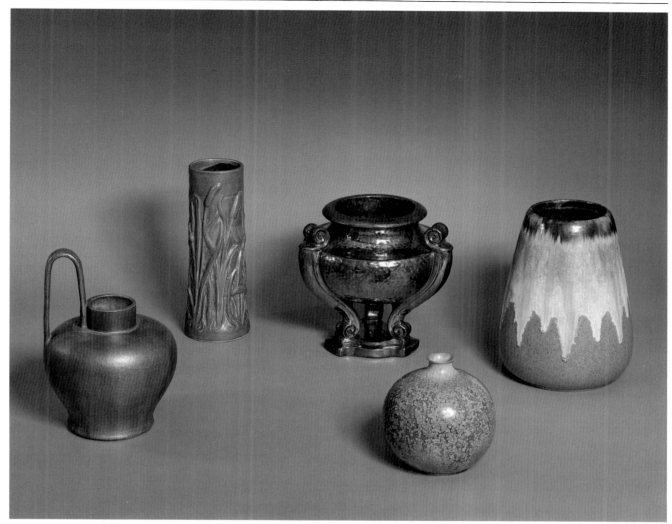

113 114 115 116 117

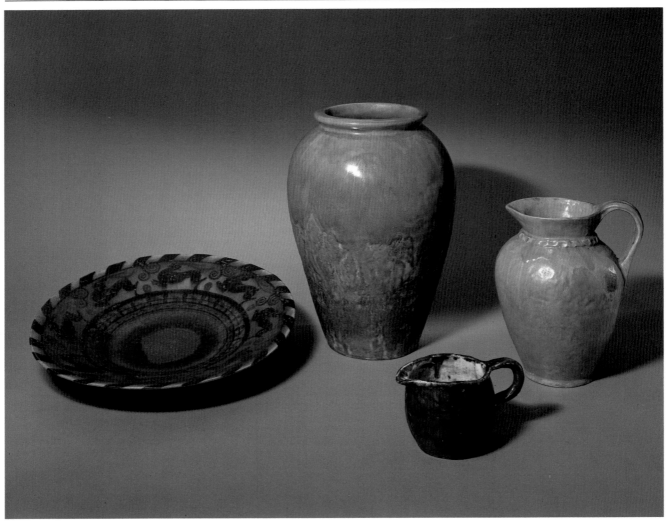

119 121 118 120

118.
Pitcher

Greenwich House Pottery,
New York City
ca. 1919-20

Executed by Paul Bess

White earthenware, crudely
modeled form with applied
handle; overall lapis blue glaze
with mottled green interior
glaze

H. 4″; O.W. 7¼″

Marks: incised *PAUL BESS*;
incised *GH* cipher; plain paper
label with price *$4.00*

Purchase 1920
20.803

The Newark Museum bought
four pieces from the Greenwich
House Potteries, three of them
several years later than this odd
little pitcher, which was also by
far the least expensive of the lot.
Not much is known about the
pottery, except that it was a
division of a crafts workshop
in New York supported by
Gertrude Vanderbilt Whitney,
and that the head of the pottery
division was Maude Robinson,
with whom the Museum corre-
sponded. It seems to have been
more a cooperative pottery,
made up of several studio pot-
ters, rather than simply artists
working for a parent firm, as at
Rookwood. Kovel (1974, 368)
lists Greenwich House as a "mis-
cellaneous" pottery studio. *Good
Furniture* magazine (March,
1924, 111) mentions
Mrs. Whitney as the patron of
Greenwich House in an article
on its furniture making division,
giving praise as well to the
pottery division.

119.
Charger

Greenwich House Pottery,
New York City
ca. 1925

Executed by Lucille Villalon

Buff eathenware of flat conical
form on high foot ring; overall
Persian-style design of antelopes
and banded ornament in blue,
turquoise and black

H. 3″; D. 16¼″

Marks: incised *LV*; incised *GH*
cipher

Purchase 1926
26.19

The 1926 purchase price of this
piece was $80.

120.
Pitcher

Greenwich House Pottery,
New York City
ca. 1925

Executed by Josephine Jewett

Buff earthenware with high
shoulders, flared rim and
molded chain motif at base of
neck; overall satin deep
turquoise glaze

H. 11″; W. 8¾″

Marks: incised *J.J.*; incised *GH*
cipher; plain paper label with
price *$35.00*

Purchase 1926
26.16

Once again the popularity of the
Egyptian turquoise faience glaze
in the 1920s is demonstrated by
this piece (see also Durant
Kilns).

121.
Vase

Greenwich House Pottery,
New York City
ca. 1925

Executed by Mary Lewis

Buff earthenware, high-
shouldered form with flared rim;
bright deep turquoise glaze,
high gloss at top, growing duller,
mottled and grayer toward base

H. 16″; D. 10½″

Marks: incised *L*; incised *GH*
cipher; incised *ML* cipher on
inside bottom; oval paper label
with price *$125*

Purchase 1926
26.17

This piece was as expensive in
its day as a comparable piece by
a celebrated master like
Adelaide Robineau, and yet
relatively little is known today
about the maker or the pottery.

122.
Vase

Grueby Faience Company,
Boston, Ma.
1900-05

White earthenware body, pear
shape with molded leaves and
flower buds on stalks; overall
pale blue-gray mat glaze

H. 7¼"; D. 4⅞"

Mark: impressed circular mark
*GRUEBY FAIENCE CO/BOSTON
USA*

Purchase 1911
11.484

Such was the extent of
John Cotton Dana's admiration
for one of America's most
recognized potteries that the
Newark Museum borrowed
thirty-four pieces directly from
William Grueby for the 1910
exhibition, *Modern American
Pottery*. Four of the pieces were
kept for the Museum collections.
The Grueby Faience name was
changed to Grueby Pottery after
1905, indicating that two of the
Museum's four pieces were at
least five years old when Dana
borrowed them for the
exhibition. Grueby wrote to the
Museum in 1913, after a
disastrous fire that destroyed his
factory and stock, to see if any
pieces remained unsold
(Newark Museum archives). The
pale blue color of this vase,
which was originally priced at
$15, is relatively rare.

123.
Vase

Grueby Pottery Company,
Boston, Ma.
ca. 1905-10

White earthenware body, pear
form with geometric band of slip
cloisonné-style teardrops and
circles at midpoint in cream
with pale ochre filling and
teardrop palmettes in border at
neck in same colors; overall dark
ochre mat glaze

H. 6⅜"; D. 4¾"

Marks: impressed circular mark
*GRUEBY POTTERY CO/BOSTON
USA*; rectangular paper pottery
label with *GRUEBY POTTERY*
printed in black and price *$18* in
ink; circular paper label with
pottery title printed in green

Purchase 1911
11.485

This is the only Grueby piece to
retain its original paper labels.
The technique of the outlined
areas on the body is extremely
rare on Grueby pottery.

124.
Vase

Grueby Pottery Company,
Boston, Ma.
ca. 1905-10

Executed by Ruth Erickson

White earthenware body with
concave neck crimped into
pentagonal form, sides modeled
with large leaves and five open
scrolled handles; overall light
green mat glaze

H. 10½"; D. 5⅞"

Marks: impressed circular mark
*GRUEBY POTTERY CO/BOSTON
USA*; incised *RE* cipher

Purchase 1911
11.487

The most expensive of the
pieces purchased from Grueby
in 1911, this vase cost $50. It
epitomizes the classic, restrained
style, mingling Art Nouveau with
the more sober English Arts and
Crafts look, that typifies
Grueby's work.

125.
Vase

Grueby Faience Company,
Boston, Ma.
1900-05

White earthenware body with
concave upper section and
barrel-form lower section
modeled with tiered leaves;
overall dark cucumber green
mat glaze

H. 10½"; D. 7⅝"

Marks: impressed circular mark
*GRUEBY FAIENCE CO/BOSTON
USA*

Purchase 1911
11.486

William Henry Grueby and
William H. Graves founded
the Grueby Faience Company,
along with designer-craftsman
George P. Kendrick, in 1897. The
first display of their wares was at
the prestigious Society of Arts
and Crafts in Boston, a place
from which the Newark Museum
purchased numerous examples
of art pottery by other makers.
The pottery was all hand-thrown
and hand-modeled, the latter
done by female students from
Boston art schools. Grueby was
famous for his mat glaze, the
first developed in America, and
the most successful, as it did not
have the complete dead flatness
of the French glazes that had
inspired him (Clark 1972, 136).
The organic vegetal forms as
well as the glazes were inspired
by the French potters
Delaherche and Chaplet.
The use of the mat glaze was a
major turning point in the
aesthetic of art pottery,
eschewing the glossy, artificial
look of the early art potters and
porcelain producers. The
original purchase price was $30.

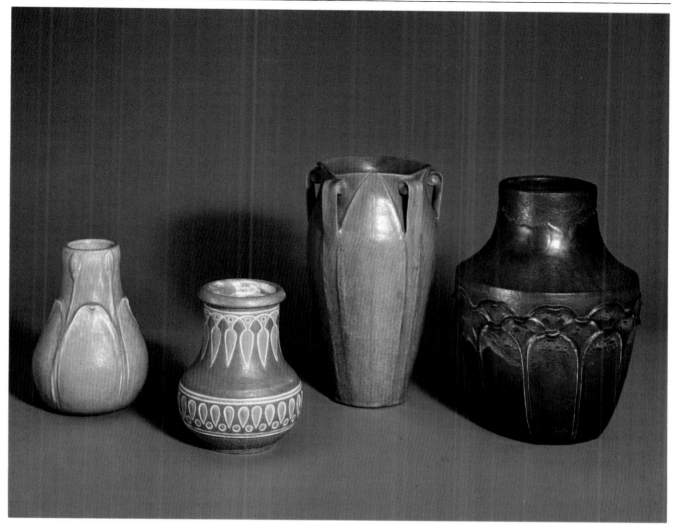

122 123 124 125

126.
Vase

Hampshire Pottery, Keene, N.H.
ca. 1910

Designed by Cadmon Robertson

White earthenware, tapered
cylindrical form with molded
vertical panels and raised neck;
overall mat dark blue-green
mottled glaze

H. 8″; D. 4″

Marks: impressed *Hampshire
Pottery*; impressed *M* within *O*
cipher

Purchase 1911

11.512

James S. Taft founded his pottery
(originally J.S. Taft & Co.) in
Keene in 1871. By the turn of the
century it had become
established by producing wares
that appealed to the Victorian
taste for Japonism, akin to work
from Trenton and Faience
Manufacturing of Brooklyn.
The style subsequently changed
with the appointment of
Taft's brother-in-law, Cadmon
Robertson, as superintendent of
the pottery. He was responsible
for the wonderful subtle glazes
typical of the firm's Arts and
Crafts style pottery. The fine
white earthenware body was
developed under Robertson as
well. The pottery closed shortly
after Robertson's death in 1914.
Pieces designed by Robertson
were marked with a cipher of an
M inside an *O*, a tribute to his
wife, Emoretta.

Newark bought their early
Hampshire pieces from Oliver
Olson in New York, who, despite
the fact that his store was named
"The Furniture Shop," dealt
largely with contemporary crafts
and pottery. This piece was
priced at $6.

127.
Vase

Hampshire Pottery, Keene, N.H.
ca. 1910

Designed by Cadmon Robertson

White earthenware body, tall
tapered cylindrical form with
narrow neck; overall mat dark
blue marbled glaze

H. 11¾″; D. 5″

Marks: impressed *Hampshire
Pottery*; impressed *MO* cipher

Purchase 1911
11.513

The original price of this piece
was $8.

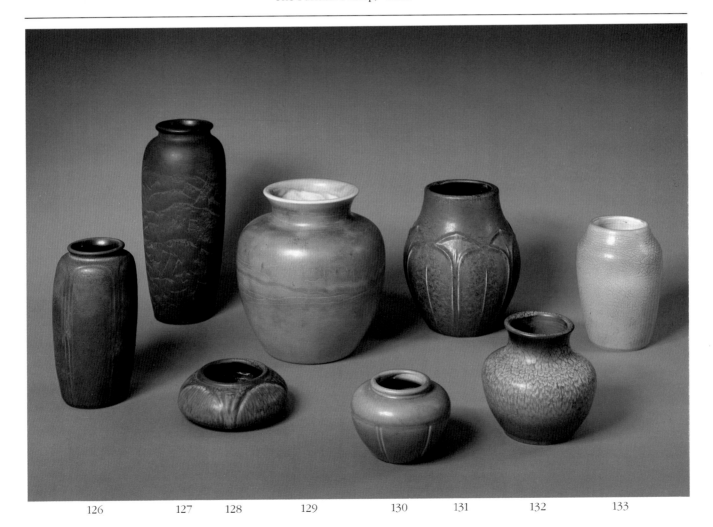

126 127 128 129 130 131 132 133

128.
Flower Bowl

Hampshire Pottery, Keene, N.H.
ca. 1910

Designed by Cadmon Robertson

White earthenware, low squat
form molded with four lobed
panels; exterior mat mottled
medium-blue glaze with glossy
bubbled black interior glaze

H. 2⅛"; D. 5½"

Marks: impressed *Hampshire
Pottery*; impressed *MO* cipher;
paper price tag *$2.75*

Purchase 1911
11.514

129.
Vase

Hampshire Pottery, Keene, N.H.
ca. 1913

Designed by Cadmon Robertson

White earthenware body, apple
form with raised flared neck;
overall satin glaze of marbled
mauve

H. 9¼"; D. 8"

Marks: impressed
Hampshire Pottery; impressed
MO cipher; paper price tag
$7.75

Purchase 1914
14.929

This vase was purchased at the
Society of Arts and Crafts,
Boston.

130.
Vase

Hampshire Pottery, Keene, N.H.
ca. 1904-14

Designed by Cadmon Robertson

White earthenware body, squat
form with raised neck ring and
body molded into five vertical
panels; overall satin mottled
mauve glaze

H. 3½"; D. 4½"

Marks: impressed *Hampshire
Pottery*; impressed *MO* cipher

Gift of Miss Mabel Kysor 1943
43.183

131.
Vase

Hampshire Pottery, Keene, N.H.
ca. 1904-14

Designed by Cadmon Robertson

White earthenware body, ovoid
form with raised neck, molded
with overlapping leaves; overall
deep blue marbled mat glaze

H. 8½"; D. 6¾"

Marks: impressed *Hampshire
Pottery*; impressed *MO* cipher

Purchase 1977
Mrs. James Cox Brady Fund
77.305

The similarity of this important
piece to Grueby's work of the
same period indicates that
Robertson was well aware of
Grueby's successful organic
forms and mat glazes.

132.
Vase

Hampshire Pottery, Keene, N.H.
ca. 1904-14

White earthenware body, squat
form with raised flared neck;
overall mat marbled dark blue-
green glaze

H. 5⅜"; D. 5⅜"

Mark: incised *Hampshire Pottery*

Gift of Mrs. Constance B. Benson
1977
77.132

133.
Vase

Hampshire Pottery, Keene, N.H.
ca. 1913

Designed by Cadmon Robertson

White earthenware body,
tapered cylindrical form narrow
at base with slightly concave
shoulder; overall mat glaze of
marbled pink-tan

H. 7", D. 4⅞"

Marks: impressed *Hampshire
Pottery*; impressed *MO* cipher

Purchase 1914
14.930

The orginal price was $2.62
from the Society of Arts and
Crafts in Boston.

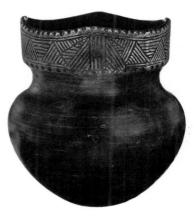

134.
Vase (Inwood Jar)

Inwood Pottery Studios,
New York City
ca. 1929

Buff earthenware body,
hourglass form; overall dark
brown mat glaze with incised
triangular motifs on crenellated
rim

H. 8¾"; D. 8"

Mark: incised
Inwood Pottery/NYC with four-
leaf clover

Gift of the Pottery 1930
30.144

Little is know about the Inwood
Pottery, located at 207th Street
and Ship Canal in Manhattan's
Inwood section. It was estab-
lished by Harry and Aimée
Leprince Voorhees around 1922.
The Inwood Jar is a copy of a
supposed Iroquois jar found by
a Reginald Bolton in the clay
bank of an excavation on 215th
Street and Amsterdam Avenue,
and was the first piece produced
by the pottery. The original In-
dian piece is reported to be in
the American Museum of Natural
History in New York City. The
clay used was Manhattan river-
bank mud (Newark Museum
archives).

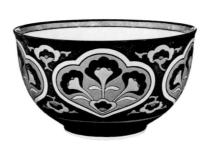

135.
Indian Fish Plate

Inwood Pottery Studios,
New York City
ca. 1930

Buff earthenware with slightly
curved brim; overall crackled
glaze with iridescence,
decorated with motif of fish in
brown and black on yellow
ground

D. 9½"

Unmarked

Purchase 1930
30.163

The original price of this piece
was $50. A small repair on the
rim was made by the pottery
before the purchase.

136.
Salad Bowl

Lenox China, Trenton, N.J.
ca. 1906-15

Decorated by M.E. Chichester

Cream porcelain body; overall
external stylized enameling of
floral or foliate forms in dark
blue, light blue, yellow, red and
medium green

H. 5⅜"; D. 9¼"

Marks: green printed Lenox
belleek palette mark (indicating
sold blank) signed in black by
artist *M.E. CHICHESTER*

Purchase 1983
Louis Bamberger Bequest Fund
83.67

This curious piece demonstrates
the close link between the
painted china tradition of the
1880s and the new art pottery
mode of the Arts and Crafts era.
Although Lenox did not produce
Arts and Crafts wares like
Grueby or others, their blanks
were used for artware decor-
ation. Chichester remains a
mystery, although it seems
probably that she or he was a
professional decorator, perhaps
in the New York area. The sober
design and muted coloring
relate closely to the work done
at European art potteries of the
same period.

137.
Portrait Tile

J. and J.G. Low Art Tile Works,
Chelsea, Ma.
ca. 1880

Executed by Arthur Osborne

White earthenware body,
molded with portrait of elderly
man in relief; overall translucent
brown glaze

Tile: 6" sq.
Frame: 8¾" sq.

Marks: impressed cipher *A*
within *O*, lower right corner of
face; impressed *F.S.A.*, upper left
corner of face; reverse marks if
any obscured by mount

Purchase 1983
Louis Bamberger Bequest Fund
83.63

Arthur Osborne was the best-
known of the modelers working
for the Low Art Tile Works.
Although the tiles were primarily
for architectural use, Osborne
produced a line of tiles called
"Plastic Sketches" meant for
display as separate entities, thus
raising them to the level of art
objects. It has been suggested
that the elderly man depicted is
Benjamin Franklin. The meaning
of *F.S.A.* is obscure, but possibly
refers to fellowship in the
Society of Antiquaries, an
English society founded in the
eighteenth century. E.A. Barber
published this design in his
great work of the early twentieth
century ([1909] 1976, 348), but
did not explain the meaning of
this mark.

138.
Tile

J.G. and J.F. Low Art Tile Works,
Chelsea, Ma.
ca. 1884-90

White earthenware with molded
Japanesque flowers; overall blue-
green translucent glaze

6¼" sq.

Marks: impressed
*J.G. & J.F. LOW./ART TILE
WORKS,/CHELSEA,/MASS.,
U.S.A./COPYRIGHT/
BY J.G. & J.F. LOW/1881*

Gift of Gary N. Berger 1983
83.37

The decorative architectural tiles
produced by the Low firm relied
heavily on Japanese ornament
and demonstrate the influence
of the English aesthetic
reformers of the 1870s.

139. A, B
Frieze Tiles

J. and J.G. Low Art Tile Works,
Chelsea, Ma.
ca. 1881-85

White earthenware with molded
decoration, one tile with
rosettes, one tile with lotus
blossoms; overall olive
translucent glaze

H. 2⅛″ and H. 3″; both L. 6″

Marks: impressed on each
*J. & J.G. LOW./PATENT ART TILE
WORKS/CHELSEA, MASS.
U.S.A./COPYRIGHT 1881
by J. & J.G. LOW.*

Purchase 1983
Louis Bamberger Bequest Fund
83.68 D,F

140.
Frieze Tile

J. and J.G. Low Art Tile Works,
Chelsea, Ma.
ca. 1881-85

White earthenware with molded
ornament; overall translucent
olive green glaze

H. 2⅛″; L. 6″

Marks: impressed as above

Purchase 1983
Louis Bamberger Bequest Fund
83.68 E

141. A,B,C
Tiles

J. and J.G. Low Art Tile Works,
Chelsea, Ma.
ca. 1881-85

White earthenware with molded
decoration; overall transparent
olive green and olive brown
glazes

Each 4¼″ sq.

Marks: A and B impressed
*J. & J.G. LOW/PATENT ART
TILE/WORKS/CHELSEA,/MASS./
U.S.A./COPYRIGHT 1881 by
J. & J.G. LOW*, except that one
shows date of 1883; C has relief
*J. & J.G. LOW/PATENT ART
TILE/WORKS/CHELSEA, MASS.*,
with an insignium of crossed
keys

Purchase 1983
Louis Bamberger Bequest Fund
83.68 A-C

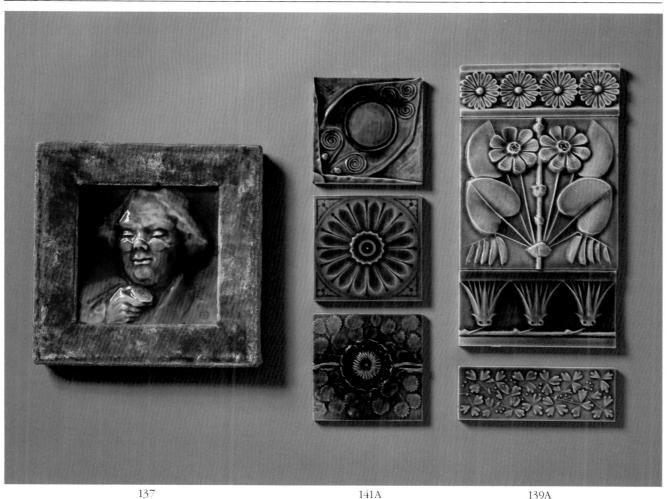

137	141A	139A
	141B	138
	141C	139B
		140

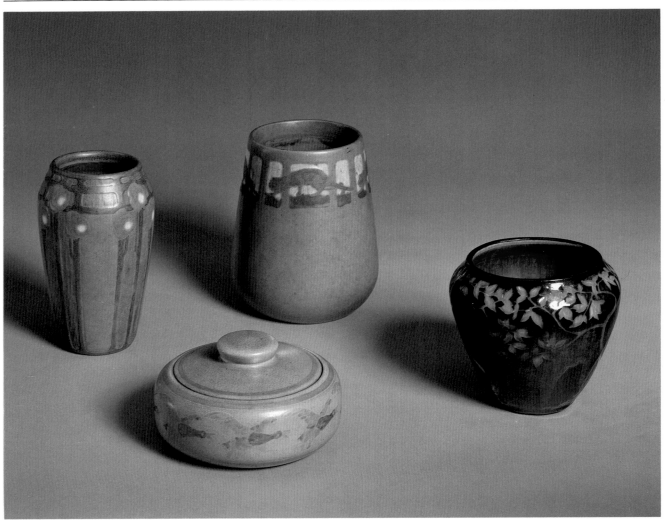

142 143 144 145

142.
Vase

Marblehead Pottery,
Marblehead, Ma.
ca. 1910

Decorated by Hannah Tutt

Buff earthenware body, tapered
form; overall mat green glaze
with four panels of stylized floral
motifs in brown, black and tan

H. 7"; D. 4"

Marks: incised pottery insignium
of frontal sailing ship in a circle
flanked by *M* and *P*; incised *HT*
cipher; oval paper pottery label
with *MARBLEHEAD POTTERY*
printed in black

Purchase 1911
11.489

Arthur E. Baggs established the
Marblehead Pottery in 1904 as a
therapeutic workshop for
convalescing patients, although
it became a self-supporting
entity by the end of its first year.
Baggs was a student of Charles
Binns at Alfred University,
and became owner of the
Marblehead Pottery in 1915. The
firm closed in 1936. This piece
cost $8.

143.
Jar

Marblehead Pottery,
Marblehead, Ma.
ca. 1910

Buff earthenware body, squat
form with domed lid; overall
gray mat glaze with series of
ducks in gray tones in flight
around the body

H. 3⅜"

Marks: incised insignium as
above; paper pottery label as
above; price tag *$6.00*

Purchase 1911
11.490

144.
Vase

Marblehead Pottery,
Marblehead, Ma.
ca. 1910

Buff earthenware body, tapered
ovoid form; overall mat green
ground with four panels with
stalking cats in dark green on
yellow and very dark green
ground

H. 7", D. 5½"

Mark: incised insignium as above

Purchase 1911
11.488

The purchase price was $10.

145.
Vase

Marblehead Pottery,
Marblehead, Ma.
1925

Designed and executed by
Arthur E. Baggs

Buff earthenware body, sharply
tapered form with wide mouth;
overall blue-black mirror glaze
with sgraffito design of wisteria
vines in turquoise and interior
lapis blue glaze

H. 5¼"; D. 5⅜"

Marks: obscured by paper label
of New York Society of Arts and
Crafts, with price *$25.00*

Purchase 1926
26.10

Arthur Baggs won the coveted
Society of Arts and Crafts medal
in Boston in 1925; this piece
may well have been one that
contributed to his selection.
Although all of the Marblehead
wares were hand-thrown and
decorated, his personal output
was more exotic and much
more limited.

146.
Vase

Marqu Potteries, New York City
ca. 1922

Buff earthenware, ovoid form
body sharply tapered at base;
overall cherry red glaze with
slight streaking

H. 6¼"; D. 4¾"

Mark: incised *MARQU*

Gift of the Pottery 1922
22.62

The striking red glaze of this
piece is a tantalizing feature.
Nothing is known about this
small pottery, which was located
at 72 West 48th Street in New
York City.

147.
Figure Tile

Moravian Pottery and
Tile Works, Doylestown, Pa.
ca. 1918

Designed by
Henry Chapman Mercer

Red earthenware, molded figure
of a peasant carrying sheaves of
wheat next to tree trunk;
polychrome glazes

H. 4¼"; W. 3¾"

Unmarked

Purchase 1919
19.37

148.
Figure Tile

Moravian Pottery and
Tile Works, Doylestown, Pa.
ca. 1918

Designed by
Henry Chapman Mercer

Red earthenware, molded figure
of a nobleman playing a cello
above Gothic foliate spray;
polychrome glazes

H. 6½"; W. 5"

Unmarked

Purchase 1919
19.38

149.
Figure Tile

Moravian Pottery and
Tile Works, Doylestown, Pa.
ca. 1918

Designed by
Henry Chapman Mercer

Red earthenware, molded relief
panel depicting a page pouring
water over Sir Walter Raleigh,
who smokes a pipe; polychrome
glazes

H. 11"; W. 10"

Mark: molded cipher of
conjoined *MOR* on face, lower
left

Purchase 1919
19.40

The original purchase price of
this rare relief was $3. These
colorful and whimsical reliefs
were apparently used to accent
the decorative scheme of a
room. Although certainly based
on medieval design, Dr. Mercer's
hand and humor figure greatly.

147
148

149

151	153	152
156 155	150	157 158
161	154	162
163	159	164
	160	

150.
Tile *(Persian Antelope)*

Moravian Pottery and
Tile Works, Doylestown, Pa.
ca. 1910

Designed by
Henry Chapman Mercer

Red earthenware, molded with
shallow relief of antelope
rampant among flowers and
foliage; rust and cream glazes on
a dark blue glaze ground

H. 7"; W. 5¾"

Unmarked

Gift of the Pottery 1911
11.429

This was the first piece of art
pottery accessioned in the
Newark Museum, and was
originally part of a 1910 loan of
thirty-seven loose tiles from the
Doylestown pottery. *Persian
Antelope* is the title given to the
design number 81 in the 1930
illustrated catalogue of the
Moravian Pottery. The clay used
for the Mercer tiles was "nothing
more than the *red brick* clay"
(correspondence with
Frank E. Swain, General
Manager, December 1929 and
January 1930; Newark Museum
archives), and the term Moravian
was a misnomer based on
Mercer's early use of a Moravian
stove plate as a tile design.
Production methods were based
on Mercer's understanding of the
manufacture of medieval
European tiles, with their
variable glazes and crude look.
Tile prices varied from sixteen
to forty cents each, according to
the complexity of colors and
glazes. The processes were
tightly guarded, and visitors to
the pottery were "not shown any
part of the process at any time"
(Swain letters). A 1930 catalogue
of all offered tiles is in the
Newark Museum archives.

151.
Tile *(Bona et Bene)*

Moravian Pottery and
Tile Works, Doylestown, Pa.
ca. 1910

Designed by
Henry Chapman Mercer

Red earthenware molded with
stylized pair of birds and Latin
motto; stained with olive-black
pigment, unglazed

5⅝" sq.

Unmarked

Gift of the Pottery 1911
11.456

This tile was listed in the 1930
catalogue as design number 255.
The Latin legend, *Non Omnia
Sed Bona Et Bene*, translates
roughly as "Not all things, but
good things well done."

152.
Tile *(Bona et Bene)*

Moravian Pottery and Tile
Works, Doylestown, Pa.
ca. 1918

Designed by
Henry Chapman Mercer

Red earthenware molded with
stylized pair of birds and Latin
motto; medium blue and buff
glazes

5¾" sq.

Unmarked

Purchase 1919
19.39

Also listed as design number 225
in the 1930 catalogue, this was
part of a second group of
Moravian tiles which came to the
Museum in 1919. (Not all of the
Museum's sixty tiles are included
in this catalogue, for space
reasons.) This version would
have cost forty cents, while its
unglazed counterpart would
have cost about half that.

153.
Tile *(Capricorn)*

Moravian Pottery and
Tile Works, Doylestown, Pa.
ca. 1918

Designed by
Henry Chapman Mercer

Red earthenware molded with
relief of the zodiac figure

Capricorn; buff glaze with blue
highlights

H. 2⅜"; W. 4"

Unmarked

Purchase 1919
19.48

The Museum has a series of
zodiac tiles designed by Mercer,
all of which are similar in
glazing and design. These sold
for twenty cents each in 1919.

154.
Molding Section *(Flower Twist)*

Moravian Pottery and
Tile Works, Doylestown, Pa.
ca. 1910

Designed by
Henry Chapman Mercer

Red earthenware molded as a
guilloche with central rosettes;
unglazed with medium blue
stain

H. 1¾"; L. 8¾"

Unmarked

Gift of the Pottery
11.452

Listed in the 1930 catalogue as
design number 364, this section
was used as a border for tile
wall or hearth treatments.

155.
Tile *(Vicar of Stowe)*

Moravian Pottery and
Tile Works, Doylestown, Pa.
ca. 1910

Designed by
Henry Chapman Mercer

Red earthenware with molded
design of stylized vase of flowers
and Latin legend; buff and
medium blue glazes

H. 3¾"; W. 3⅞"

Unmarked

Gift of the Pottery 1911
11.438

This tile was listed as design
number 58 in the 1930
catalogue, and was adapted from
a fourteenth-century design
found at Castle Acre Priory,
Norfolk. The legend reads, "Pray
for the soul of Father Nicholas of
Stowe."

156.
Tile *(The Etin)*

Moravian Pottery and
Tile Works, Doylestown, Pa.
ca. 1910

Designed by
Henry Chapman Mercer

Red earthenware with molded
design of lion's face; dark green
and buff glazes

5″ sq.

Unmarked

Gift of the Pottery 1911
11.441

This was listed as design
number 160 in the 1930
catalogue, and was based on an
ancient British tile.

157.
Tile *(Little Fox)*

Moravian Pottery and
Tile Works, Doylestown, Pa.
ca. 1910

Designed by
Henry Chapman Mercer

Red earthenware with molded
design of fox and vines; glossy
yellow and dark green glazes

H. 3½″; W. 2¾″

Unmarked

Gift of the Pottery 1911
11.433

This tile was listed as design
number 39 in the 1930
catalogue.

158.
Tile *(Arms of Castille)*

Moravian Pottery and
Tile Works, Doylestown, Pa.
ca. 1910

Designed by
Henry Chapman Mercer

Red earthenware with molded
pattern of a three-towered castle
within an Islamic star; yellow
and dark green glazes

4¾″ sq.

Unmarked

Gift of the Pottery 1911
11.465

Listed as design number 113 in
the 1930 catalogue, the design of
this tile was based on the
thirteenth-century Alcazar at
Castille.

159.
Tile

Moravian Pottery and
Tile Works, Doylestown, Pa.
ca. 1910

Designed by
Henry Chapman Mercer

Red earthenware with molded
design of scroll work around the
crest of a castle and swan; ochre
and dark green glazes

H. 7″; W. 5¾″

Unmarked

Gift of the Pottery 1911
11.430

The Latin legend reads *Fluminis
Impetus Letificat Civitatem Dei*,
which translates, "There is a
river the streams whereof make
glad the city of God." The design
is based on a sixteenth-century
Spanish tile.

160.
Tile *(Brocade Hawk)*

Moravian Pottery and
Tile Works, Doylestown, Pa.
ca. 1910

Designed by
Henry Chapman Mercer

Red earthenware molded
heraldic figure of a hawk facing
right; buff and blue glazes

H. 4¼″; W. 4¾″

Unmarked

Gift of the Pottery 1911
11.458

This tile was listed as design
number 368 in the 1930
catalogue.

161.
Tile *(Byzantine Four Flowers)*

Moravian Pottery and
Tile Works, Doylestown, Pa.
ca. 1910

Designed by
Henry Chapman Mercer

Red earthenware molded with
four foliate motifs arranged in
quadrants; yellow and dark
green glazes

H. 7⅛″; W. 5⅞″

Unmarked

Gift of the Pottery 1911
11.462

Design number 35 in the 1930
catalogue, this was the more
costly version (forty cents) of the
unglazed example (sixteen cents).

162.
Tile *(Byzantine Four Flowers)*

Moravian Pottery and
Tile Works, Doylestown, Pa.
ca. 1910

Designed by
Henry Chapman Mercer

Red earthenware molded with
design of four foliate motifs
arranged in quadrants; olive-
black stain, unglazed

H. 6¾″; W. 5⅝″

Unmarked

Gift of the Pottery 1911
11.463

Listed as design number 35 in
the 1930 catalogue, the motif
was taken from a Byzantine
candelabrum at Lucca.

163.
Tile *(Knight)*

Moravian Pottery and
Tile Works, Doylestown, Pa.
ca. 1918

Designed by
Henry Chapman Mercer

Red earthenware molded with
design of medieval knight with
axe and helmet beneath an arch
with *KNIGHT* above; buff and
dark green glazes

4″ sq.

Unmarked

Purchase 1919
19.56

164.
Tile *(Merchant)*

Moravian Pottery and
Tile Works, Doylestown, Pa.
ca. 1918

Designed by
Henry Chapman Mercer

Red earthenware molded with
design of robed man with scales
and a moneypurse beneath an
arch with *MERCHANT* above;
buff and dark green glazes

4″ sq.

Unmarked

Purchase 1919
19.64

165.
Scenic Relief
(Montezuma's Gardens)

Moravian Pottery and
Tile Works, Doylestown, Pa.
ca. 1918

Designed by
Henry Chapman Mercer

Ten pieces of unglazed terracotta
of various colors including gray,
rust, brown and buff, molded
scene of columns framing
buildings and foliage with
legend *Gardens of Montezuma*

H. 10½"; O.W. 17"

Mark: molded cipher of
conjoined *MOR* in relief on
central balustrade section

Purchase 1919
19.66 A-J

The design for this came from
pictographs and symbols found
by Dr. Mercer in manuscripts
and codices of Mexico and the
Yucatan. The tiles were first used
in the Mexican room in his
house, Font Hill (correspondence
from Frank E. Swain, General
Manager, January 1930, Newark
Museum archives).

166.
Cup

Moravian Pottery and
Tile Works, Doylestown, Pa.
ca. 1918

Designed by
Henry Chapman Mercer

Red earthenware, tapered
hexagonal form with each side
slightly molded into two panels;
overall glaze of mottled blue and
cream with brown body showing
through clear glaze

H. 2"; D. 3½"

Unmarked

Purchase 1919
19.96

John Cotton Dana purchased
this piece for the Museum at the
Moravian Pottery for thirty-five
cents.

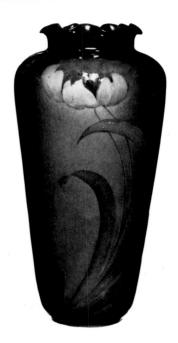

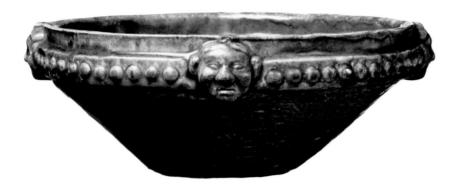

167.
Bowl

Moravian Pottery and
Tile Works, Doylestown, Pa.
ca. 1918

Red earthenware, flattened
inverted cone form with molded
band of nail heads at rim,
punctuated by four grotesque
masks; overall deep blue-green
mottled glaze

H. 3½", D. 8¾"

Unmarked

Purchase 1919
19.97

The original purchase price
was $2.

168.
Vase

Mott Pottery Works, Trenton, N.J.
ca. 1890-1900

"Tokalon" ware

White porcelain; overall sepia
glaze and slip-painted flower in
rust and green

H. 9¼"; D. 4⅝"

Mark: printed in brown on base
MOTT'S/TOKALON

Purchase 1976
W. Clark Symington
Bequest Fund
76.187

The Mott Works in Trenton
was concerned primarily with
sanitary fixtures, but produced a
very limited line of artwares in
imitation of the late-century
Rookwood manner. The only
other known pieces are in the
collection of the New Jersey
State Museum, and those were
made for members of the
Mott family. Commercial and
technical problems probably
precluded any long-term success
for this rare pottery.

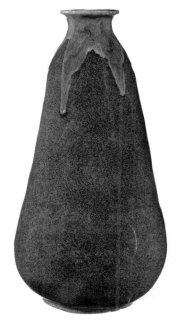

169.
Tile

Mueller Mosaic Tile Company,
Trenton, N.J.
ca. 1934-35

Red earthenware with shallow
relief decoration of a fleur-de-lis;
mat glazes of lapis blue, rust red,
navy blue and ochre

6″ sq.

Unmarked

Gift of
Mueller Mosaic Tile Company
1935
35.118

Herman Mueller established an
architectural tile firm in Trenton
in 1908, having previously
worked with the Mosaic Tile
Company in Zanesville, Ohio.
Mueller's output was largely
architectural and included tiles
for subway stations in New York
and Newark. The Museum also
owns a panel designed by artist
Domenico Mortellito in 1935 for
Newark's own subway system,
measuring 52½ by 45¾ inches
(35.113).

170.
Frieze Tile

Mueller Mosaic Tile Company,
Trenton, N.J.
ca. 1934-35

Red earthenware with molded
running pattern of grape
clusters, tendrils and leaves;
purple, pale green and deep
blue mat glazes framed with
ochre mat glaze

H. 4″; L. 5⅞″

Unmarked

Gift of
Mueller Mosaic Tile Company
1935
35.120

Mueller lent the Museum a
series of glaze samples and
unglazed tiles for an exhibit on
processes in 1935. The Mueller
firm closed in 1938.

171.
Vase

(Mrs.) Anne Wells Munger,
Worcester, Ma.
ca. 1913-14

Buff stoneware body, eggplant
shape with narrow neck; overall
satin green-tan mottled glaze,
partly covered at rim and neck
with tan drip glaze

H. 9″; D. 4⅛″

Mark: incised cipher of
conjoined *AWM*

Purchase 1914

14.926

Nothing is known about
Anne Munger except that she
was also a painter (*Art Annual*
1914). Her skill as a potter can be
seen in this charming vase, with
carefully controlled glaze effects.
The purchase price for this
piece, from the Society of Arts
and Crafts in Boston, was $11.40.

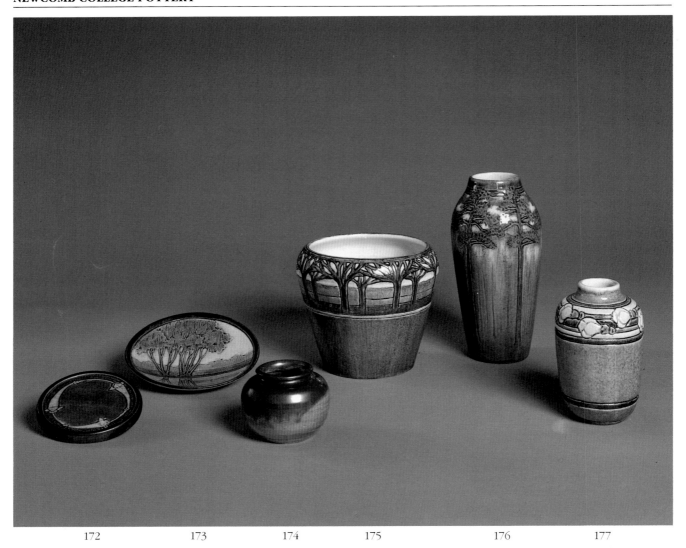

172 173 174 175 176 177

172.
Coaster Tile

Newcomb College Pottery,
New Orleans, La.
ca. 1910

Decorated by Alma Mason;
Joseph Meyer, potter

Buff earthenware of circular
form with incised pattern of
three trumpet-shaped flower
blossoms in a circle; mat blue
and pale blue glazes

D. 4"

Marks: impressed *NC* cipher;
incised *A.M.* stained blue;
impressed *JM* cipher and *B*;
paper label with price *$1.00*

Purchase 1911

11.495

This coaster or tile represents an
early use of the mat glaze, which
Paul E. Cox had only introduced
at the Newcomb Pottery in about
1910. Alma Mason was one of the
many student decorators at the
pottery (Evans, 1974, 54-55).

173.
Saucer *(After the Rain)*

Newcomb College Pottery,
New Orleans, La.
ca. 1910

Decorated by
Anna Frances Simpson;
Joseph Meyer, potter

Buff earthenware body with
overall scene of cypress trees in
low relief; green, blue and
yellow glazes

D. 5¾"

Marks: impressed *NC* cipher
stained blue; incised *AFS* stained
blue; impressed *JM* cipher;
paper label reading *After the
Rain/$3.00* in pencil

Purchase 1911

11.494

Each handmade piece of
Newcomb College Pottery
was unique. The decoration,
inspired by local flora and fauna
was largely done by the female
students of Newcomb College
(now part of Tulane University).
The potting was done by
Joseph F. Meyer and Paul E. Cox.
The latter had been a student of
Charles Binns at Alfred
University.

174.
Bud Vase

Newcomb College Pottery,
New Orleans, La.
ca. 1910

Decorator unknown;
Joseph Meyer, potter

Buff earthenware, globular form
with raised rim; overall red glaze
shading from deep iridescent
maroon at top to fiery orange-
red at base

H. 2¾"; D. 3¼"

Marks: *NC* cipher; impressed
G and *JM* cipher; paper price tag
$2.00

Purchase 1911

11.492

This is the least typical of the
seven pieces of Newcomb
pottery purchased after the
Museum's 1910-11 exhibition. Of
special interest are the visible
rings, as evidence of the hand-
throwing process, and the
fine red glaze, always an
achievement for a potter.

175.
Vase

Newcomb College Pottery,
New Orleans, La.
ca. 1910

Decorated by
Maria Hoa LeBlanc;
Joseph Meyer, potter

Buff earthenware body with
wide mouth and tapered base;
design of stylized china ball
trees in band at top in blue on
blue-green and yellow ground

H. 6½"; D. 5½"

Marks: impressed *NC* cipher
stained blue; incised *MHLeB*
cipher stained blue; impressed
JM cipher; square paper pottery
label printed *NEWCOMB
POTTERY/Subject/Designs are
not duplicated./NEW ORLEANS.*
in black, with title *China Ball
Tree* in red pencil; paper price
tag *$5.00*

Purchase 1911

11.498

Newark originally borrowed
eight pieces from the New York
antiques and art dealer
Oliver Olson in 1910, and
subsequently purchased four
from him in 1911. Two additional
pieces were acquired later in
1911. Olson seems to have

been the Newcomb dealer in
New York. Museum files contain
correspondence concerning the
loan and purchases with the
founder of the pottery,
Ellsworth Woodward.

176.
Vase

Newcomb College Pottery,
New Orleans, La.
ca. 1910

Decorated by
Maria Hoa LeBlanc;
Joseph Meyer, potter

Buff earthenware body, ovoid
form with narrow rim and
tapered base; design of five pine
trees in shallow relief dividing
body into five panels; glazes in
shades of blue

H. 8½"; D. 3⅞"

Marks: impressed *NC* cipher
stained blue; *MHLeB* cipher
painted in blue; impressed
Q and *JM* ciphers obscured by
paper label with price *$6.00*

Purchase 1911

11.496

177.
Vase

Newcomb College Pottery,
New Orleans, La.
ca. 1910

Decorated by Leona Nicholson;
Joseph Meyer, potter

Buff earthenware body,
cylindrical form with narrow
mouth and rounded bottom;
green-blue background glaze
with incised band at bottom;
shoulder has band of incised
crocus (?) blossoms and stems in
yellow, white and green.

H. 5½"; D. 3½"

Marks: impressed *NC* cipher
stained blue; *LN* cipher painted
in blue; impressed *JM* cipher;
paper price tag *$3.50*

Purchase 1911

11.497

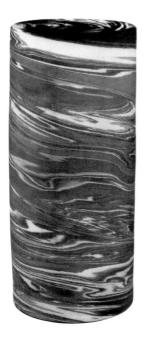
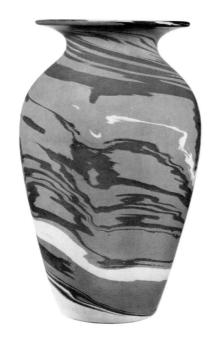

178.
Vase

Niloak Pottery, Benton, Ar.
ca. 1910-20

Marbled earthenware body in
shades of cream, brown, blue
and gray, cylindrical form;
unglazed exterior with
transparent interior glaze

H. 8"; D. 3⅜"

Mark: impressed *NILOAK* in
"artistic" letters

Purchase 1972
Alice W. Kendall Bequest Fund
72.365

179.
Vase

Niloak Pottery, Benton, Ar.
ca. 1910-20

Marbled earthenware body in
shades of red, cream, blue and
tan, classical baluster form with
flared rim; unglazed exterior
with transparent interior glaze

H. 8⅜"; D. 5"

Marks: impressed *NILOAK* in
"artistic" letters; partial blue and
white circular paper pottery
label reading *NILOAK*

Purchase 1983
Louis Bamberger Bequest Fund
83.58

The Niloak ("kaolin" spelled
backward) Pottery was founded
by Charles Dean Hyten in 1909.
Hyten successfully formulated
the means to mix native
Arkansas clays into a marbled
body without separation,
creating this unique ware. The
process of throwing the pieces
produced the pattern. The peak
production phase of the pottery
ended with the Depression and
Hyten's death in 1944. Simple
classical forms were the rule, as
seen in these examples. The line
was named "Mission Ware."

180.
Mantel Vases (pair)

Odell and Booth Brothers,
Tarrytown, N.Y.
ca. 1880-84

White earthenware body,
circular lentoid form;
underglaze slip decoration of
Japanesque flowers in peach and
blue on a gray and black ground

Each H. 8½"; W. 7¾"

Marks: each impressed *O&BB* on
foot

Purchase 1983
Louis Bamberger Bequest Fund
83.65

The Japonism of the early art
potters is evident here in the
muted colors and the lentoid
form of these rare vases, as well
as in the asymmetrical layout of
the design. Charles M. Odell was
the business partner in this
short-lived firm, while Walter
and Henry Booth, natives of
Staffordshire, handled the
technical and artistic aspects.
The underglaze technique used
by the firm was like that of the
French barbotine wares in
which slips were made from
ground fired clays. The
technique evolved by
Mary Louise McLaughlin in
Cincinnati used unfired clay
slips (Keno 1980, 96-101). These
vases relate closely to Miss
McLaughlin's early work in
Cincinnati, and epitomize the
first true stirrings of the art
pottery movement in America
(Clark 1972, 120, fig. 156).

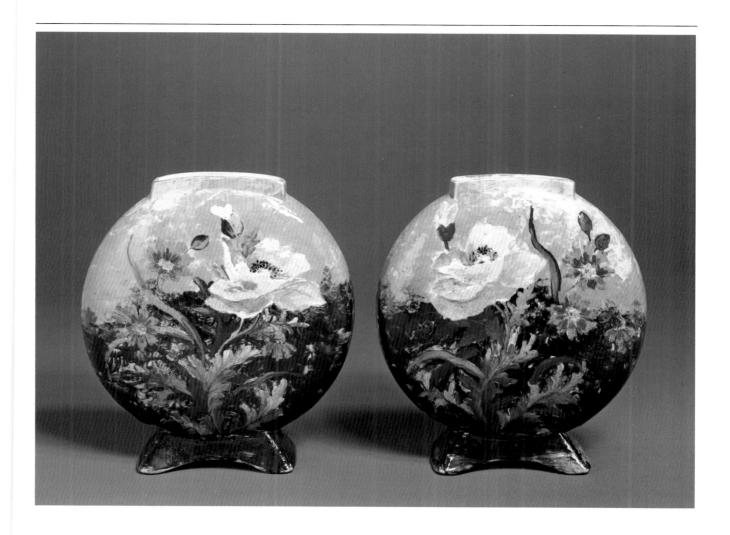

181.
Plate with Flower Holder

Old Dover Pottery, Durham, N.H.
ca. 1937-38

Executed by
Mrs. Kelsea Griffin Gillette

Red earthenware body with
deeply sloped sides and lobed
edges; overall satin mottled gray-
blue and gray-pink glaze; flower
holder of loosely-modeled
cylinders has same glaze

Plate: D. 8¼"
Holder: H. 1⅞"

Mark: impressed seahorse on
both parts

Gift of Alice W. Kendall 1938
38.587

Mrs. Gillette produced her own
clay and glazes from local
sources in New Hampshire,
creating an entirely indigenous
product. Like local potters such
as William Walley and Russell
Crook, she worked as an artist
more than as a commercial
potter, indicative of the growing
division between mass-produced
pottery and handmade art wares.

182.
Vase

Omar Khayyam Pottery,
Candler, N.C.
ca. 1920

Executed by
Oscar Louis Bachelder

Buff earthenware, squat form
with broad mouth; overall shiny
mottled black and brown glaze

H. 5¼″; D. 5⅞″

Mark: impressed *OLB* cipher

Purchase 1920
20.771

Oscar Bachelder was a well-
known North Carolina potter,
and taught Paul Saint-Gaudens.
This piece was bought for $3
from the Woodstock Craft Shop
in 1920 by John Cotton Dana. At
the time the shop did not know
the identity of the potter.

183.
Vase

Omar Khayyam Pottery,
Candler, N.C.
ca. 1923-24

Executed by
Oscar Louis Bachelder

Buff earthenware, high-
shouldered ovoid form; overall
shiny black glaze with brown at
edges

H. 4⅛″; D. 4⅛″

Mark: impressed *OLB* cipher

Purchase 1924
24.200

Paul Saint-Gaudens suggested in
1924 that the Museum buy this
piece by his mentor and teacher.
The asking price was $5
(Newark Museum archives).
Bachelder used only one glaze,
relying on the firing to produce
different effects on each piece.

184.
Tile

Ott and Brewer, Trenton N.J.
ca. 1870-80

White earthenware with gelatin
cast photographic image of
Admiral Perry transferring the
colors during the Battle of Lake
Erie, 1813; translucent blue glaze

H. 3⅞"; L. 5"

Unmarked

Purchase 1981
John J. O'Neill Bequest Fund
81.332

This is an example of the
experimental tiles which were
produced at Ott and Brewer's
Trenton plant but were never
commercially manufactured.
The technique of forming
a tile mold from a gelatin
photographic plate is an
indication of the quest for
artistic design in tile-making.

185.
Dessert Plate

Ott and Brewer, Trenton, N.J.
ca. 1890-95

White porcelain; overglaze three-
color gold and polychrome
enamel decoration of passion
flowers

8" sq.

Marks: printed *O&B* with half-
moon in red; printed
TIFFANY & CO/BELLEEK

Gift of Mrs. W. Clark Symington
1965
65.8M

Although the art porcelains of
the 1880s and 1890s are usually
considered separately from art
pottery, they in fact were part of
the same initial artistic impulse.
In addition to their aesthetic
concerns, porcelain makers such
as Ott and Brewer sought the
same quality and craftsmanship
as the early potters at Rookwood
and Chelsea Keramic, and the
porcelain workers attained
similar artistic status within the
firm. The technical problems of
controlling glaze, enamels and
body were much the same for
porcelain makers and potters. In
fact, much of the first art pottery
decoration was done on
porcelain bodies, and potters
like Adelaide Robineau always
used porcelain as their favored
medium. The Newark Museum
owns a large collection of New

Jersey belleek wares in this
mode; this is the only example
included here, part of a large
dessert service. The Japanesque
asymmetry and superb hand
decoration of this plate are
closely tied to the early art
wares of Cincinnati.

186.
Tile

Ott and Brewer, Trenton, N.J.
ca. 1892

Executed by Isaac Broome

White earthenware with molded
design of George Washington in
profile with background of stars;
overall translucent gray glaze

12" sq.

Mark: impressed *BROOME/92*
on face

Purchase 1969
Eva Walter Kahn Bequest Fund
69.86

Designed to commemorate the
one-hundredth anniversary of
Washington's second term as
president, this tile would have
been seen as a work of art
rather than simply as a piece of
pottery. The design relates to
sculptural work done for
commemorative plaques and
medals during the same
period by artists such as
Augustus Saint-Gaudens.

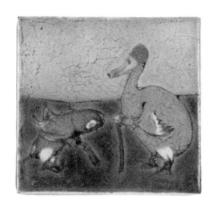

187.
Tile

C. Pardee Works,
Perth Amboy, N.J.
ca. 1890

White earthenware with relief
portrait of Grover Cleveland;
overall deep purple translucent
glaze

6" sq.

Mark: relief *C. PARDEE. WORKS.
PERTH AMBOY N.J*

Purchase 1923
23.2310

188.
Tile

C. Pardee Works,
Perth Amboy, N.J.
ca. 1921

Buff earthenware with scene of
animal characters from *Alice in
Wonderland*; with cloisonné-
style mat glazes in green and tan

4⅜" sq.

Mark: full relief mark as above

Gift of
Mr. and Mrs. Christopher Forbes
1983
83.55

When the Grueby Pottery in
Boston failed in 1921, it was
purchased by the Pardee tile
works in New Jersey, which
began to produce tiles in the
Grueby manner soon thereafter.
The finely controlled glazes
mastered by Grueby are evident
in this unusual example.

189.
Bowl

Paul Revere Pottery, Boston, Ma.
ca. 1910

Buff body, hemispherical form;
deep blue-green glaze with
border of incised parallelogram
lozenges framed in white

H. 2½"; D. 4¼"

Marks: *S.E.G.* in ink; blue and
white rectangular paper label of
Bowl Shop reading *BOWL•SHOP*
over *S•E•G•* within a bowl, over
*18 HULL ST/BOSTON•MASS/
PRICE*; ink cipher of artist *RF* in
rectangle

Purchase 1911
11.499

The Saturday Evening Girls was
an association of young
immigrant women who
decorated pottery as part of a
program of craft activities on
Saturday evenings. The Paul
Revere Pottery grew out of this
association. Edith Brown acted
as director, and gradually began
to train women with high school
degrees to undertake the more
complex operations in the
pottery. As at Newcomb, men
did the hard labor of throwing
the pots and firing the kiln. The
products of the pottery were
sold under the name of the Bowl
Shop, and the women's mark,
S.E.G., was used on each piece
as well. A large part of the firm's
early production was incised
children's dishes.

Newark borrowed thirty-two
pieces from Edith Brown,
proprietress of the Bowl Shop in
Boston, for the 1910 exhibition.
Five of these pieces were
purchased in 1911, and other
examples were bought by the
Newark Free Public Library. This
bowl cost $1.

190.
Bowl

Paul Revere Pottery, Boston, Ma.
ca. 1910

Buff hemispherical body with
slightly flattened sides; mat
cream interior glaze, speckled
green exterior incised with band
of rabbits in white

H. 2¼"; D. 5½"

Mark: *S.E.G.* in ink, partially
legible

Purchase 1911
11.500

The price for this piece was $2.

191.
Bowl

Paul Revere Pottery, Boston, Ma.
ca. 1910

Buff hemispherical body; mat
ivory interior glaze, mat blue,
green and gray exterior glazes
incised with border of ducks in
white below white rim

H. 2¼"; D. 4¼"

Marks: *S.E.G.* in ink, partial Bowl
Shop label as above; initials of
unknown artist *FL* in ink

Purchase 1911
11.501

The price for this piece was
$1.50.

192.
Bowl

Paul Revere Pottery, Boston, Ma.
ca. 1910

Buff hemispherical body;
interior mat cream glaze, cream
exterior banded with yellow
with incised border of pairs of
roosters

H. 2¼"; D. 5½"

Marks: obscured by partial Bowl
Shop label as above; ink cipher
of unknown artist *GG* in
rectangle

Purchase 1911
11.504

The price of this bowl was $2.50.

193.
Plate

Paul Revere Pottery, Boston, Ma.
ca. 1910

Buff body; mat cream crackled
glaze and gray-blue mat border
incised with stylized flowers in
white

D. 7¾"

Marks: partially illegible *S.E.G.*;
paper Bowl Shop label as above;
ink cipher of unknown artist *E.L.*

Purchase 1911
11.503

The purchase price of this piece
was $2.50.

194.
Plate

Paul Revere Pottery, Boston, Ma.
ca. 1917

Buff earthenware; overall satin
yellow glaze, white rim with
black line and black swastika at
top

D. 8½"

Marks: *S.E.G.* in ink; paper label
of Bowl Shop in Brighton (same
as Boston label but printed in
black on white and bearing
Brighton address)

Gift of Miss Edith Guerrier 1919
19.227

Edith Guerrier, the donor of this
plate, was a Boston librarian
involved in the founding of the
Saturday Evening Girls. She
lived with the pottery's director,
Edith Brown, and was closely
associated with the pottery's
early years (Newark Museum
archives and Kovel 1974, 188).
The swastika, an ancient symbol,
had not yet acquired its sinister
modern significance.

195.
Bowl

Paul Revere Pottery,
Brighton, Ma.
ca. 1915

Buff earthenware body; overall
cream satin glaze, incised
external border of landscape
with trees, in blue and green

H. 2⅛"; D. 4¼"

Mark: *S.E.G.* in ink

Gift of Jack T. Ericson 1971
71.57

196.
Vase

Paul Revere Pottery,
Brighton, Ma.
ca. 1924

Buff stoneware body, tall ovoid
form; medium blue glaze with
white flecking dripping over tan
lower section with clear glaze

H. 10⅜"; D. 5¾"

Marks: impressed circular mark
of horse and rider with *BOSTON*
above and *PAUL REVERE/
POTTERY* below

Purchase 1983
Louis Bamberger Bequest Fund
83.54

In 1915 the pottery moved from
Boston to Brighton, into a new

building given by Mrs. James
Storrow, longtime benefactor of
the Saturday Evening Girls. Edith
Brown designed the building. In
addition to the now-famous
children's dishes, into which
category fall most of Newark's
examples, the firm produced
conventional art wares, some
with fine drip glazes in the
manner of the Robertsons at
Chelsea and Dedham.

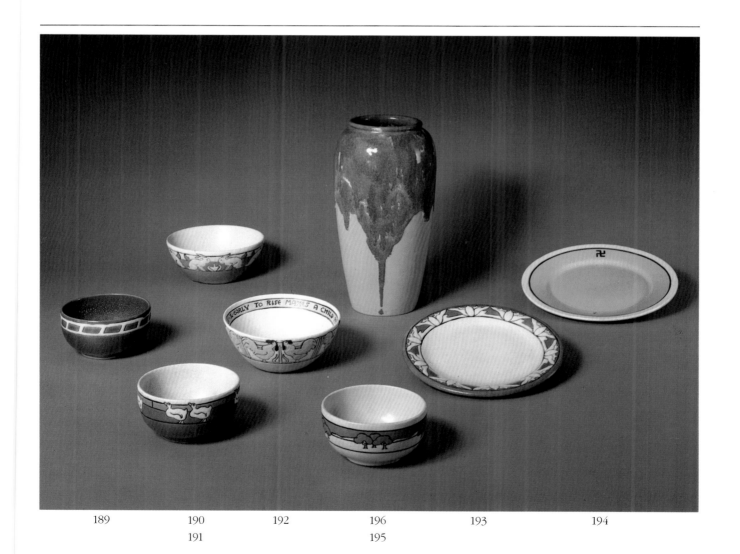

189 190 192 196 193 194
 191 195

197.
Bowl

Paul Revere Pottery, Boston, Ma.
ca. 1914

Hemispherical buff earthenware
body; overall yellow glaze with
orange peel texture

H. 5⅛″; D. 11½″

Unmarked

Purchase 1914
14.921

Newark purchased two pieces of
plain pottery from the Society of
Arts and Crafts in Boston in
1914. This bowl cost $5.

198.
Bowl

Paul Revere Pottery, Boston, Ma.
ca. 1914

Hemispherical buff earthenware
body; overall smooth black glaze

H. 3"; D. 10⅝"

Mark: faint *S.E.G.* ink mark on
glaze

Purchase 1914
14.922

The original price of this piece
was $4.

199.
Vase

Pewabic Pottery, Detroit, Mi.
1913-14

Executed by Mary Chase Perry

Earthenware body, tall tapered
cylindrical form with pinched
neck; overall iridescent gold
glaze

H. 10⅛"; D. 5⅛"

Marks: obscured by glaze

Purchase 1914
14.924

Mary Chase Perry began the
Pewabic Pottery in 1903,
inspired by William Grueby.
Pewabic was the Chippewa word
for "clay in copper color," and
the name of a Michigan river.
The last of her major
innovations was the iridescent
gold glaze, of which this is an
example. The vase was
purchased from the Society of
Arts and Crafts, Boston, for
$13.30.

200.
Vase

Pewabic Pottery, Detroit, Mi.
1925

Buff earthenware body, squat
bottle form with tall flared neck;
overall orange glaze with yellow
interior glaze

H. 9"; D. 6"

Marks: obscured by glaze

Purchase 1926
26.9

The price of this piece, at New
York's Society of Arts and Crafts,
was $18.

201.
Pitcher

Poillon Pottery, Woodbridge, N.J.
ca. 1904-10

White earthenware body, flat-
bottomed pear form with square
upper section, molded with
grotesque masks on each side;
overall glaze of translucent
mustard yellow

H. 4¾"; O.W. 5½"

Marks: incised *CLP* cipher

Gift of
Mr. and Mrs. Christopher Forbes
1983
83.61

202.
Toby Pitcher

Poillon Pottery, Woodbridge, N.J.
ca. 1904-10

White earthenware body,
globular Toby figure form with
tricornered hat; overall
translucent blue-green glaze

H. 4¼"; W. 4½"

Marks: incised *CLP* cipher

Purchase 1974
The Members' Fund
74.76

Clara Louise Poillon was a well-
to-do lady with an interest in
ceramics who managed her
small pottery in New Jersey and
developed the glazes for her
wares. Although she did not do
the potting herself, the bodies
and glazes were her specialty.
The Museum borrowed
examples of her garden pottery
for the 1915 exhibit, *Clay
Products of New Jersey*, but did
not purchase any. She retired
from the firm in 1928, but
continued to exhibit her wares
until her death in 1936.

203.
Tile

Providential Tile Works,
Trenton, N.J.
ca. 1891-1900

White earthenware with molded
pattern of three roses; overall
mottled olive-tan translucent
glaze

6" sq.

Mark: title in relief
*PROVIDENTIAL TILE WORKS/
TRENTON/NJ*

Gift of
Mr. and Mrs. Patrick O. Roberts
1969
69.122

204.
Tile

Providential Tile Works,
Trenton, N.J.
ca. 1886-95

Designed by Isaac Broome

White earthenware with molded
design of birds in nest; overall
brown transparent glaze;
mounted in incised slate
surround

Tile: 6⅝" sq.
Mount: H. 10¾"; W. 9"

Marks: full title in relief as above;
relief mark *BROOME. KIRKHAM.
& ROBINSON*

Purchase 1983
Louis Bamberger Bequest Fund
83.62

Isaac Broome, celebrated sculp-
tor and modeler for numerous
ceramic firms in the United
States, joined James Robinson
and Joseph Kirkham in the pro-
duction of this unusual tile. It
retains the original architectural
mount, probably from a fire-
place mantel.

205.
Vase

Red Wing Pottery, Red Wing, Mn.
ca. 1936-40

Light earthenware body,
cylindrical form tapered at both
ends, molded with stylized
Art Deco relief of figures and
plants; overall burgundy-red
glaze with gray-green interior
glaze

H. 10¼"; D. 4⅛"

Mark: impressed *RED WING
U.S.A./1148*

Purchase 1971
Thomas L. Raymond Bequest
Fund
71.68

Even the mass market art ware
producers turned out high-
quality design and fine glazes, as
evidenced by this example of
Red Wing. The characteristic
geometric styling of this
1930s vase demonstrates the
continued, if diluted, effort to
produce affordable art ware that
nevertheless maintained
standards of quality and design.

206.
Bud Vase

Adelaide Alsop Robineau,
Syracuse, N.Y.
ca. 1910

White porcelain body, squat
form with tall flared neck;
overall sky blue crystalline glaze
with touches of gray

H. 6¼"; D. 3"

Marks: circular relief *AR* cipher;
impressed date *1910*

Purchase 1914
14.933

Newark purchased three small
examples of Adelaide Robineau's
celebrated pottery at the Society
of Arts and Crafts in Boston in
1914. This bud vase is the largest
of the three and cost $19.
Robineau's perfectionist
techniques and her remarkable
crystalline glazes are evident.
Not a prolific potter, she sold
only about six hundred of her
pieces. Newark was the first
museum to purchase her
work for its permanent
collection (Weiss 1981, 188).
Adelaide Robineau was born in
1865 in Middletown,
Connecticut, but lived in
Syracuse for most of her life. She
died in 1929.

207.
Bud Vase

Adelaide Alsop Robineau,
Syracuse, N.Y.
ca. 1913-14

White porcelain body, squat
globular form with small raised
mouth and foot; overall finely-
shaded leaf green glaze with
touches of oxblood at rim and
brown at foot

H. 3"; D. 3½"

Mark: circular raised *AR* cipher

Purchase 1914
14.931

At $19, this tiny vase was the
most expensive relative to its
size of the three Robineau vases
purchased by the Museum from
the Boston Society of Arts and
Crafts, probably because of the
difficult combination of glazes.
Mrs. Robineau would often
refire pieces until they turned
out as she wished, or else
exploded (Evans 1974, 245).

208.
Bud Vase

Adelaide Alsop Robineau,
Syracuse, N.Y.
ca. 1913-14

White porcelain body, bottle
form; overall pale yellow
crystalline glaze

H. 4⅝"; D. 2½"

Mark: circular raised *AR* cipher

Purchase 1914
14.932

Robineau's work was far more
expensive than other art pottery
works of comparable size,
indicating the great amount of
work involved. This vase cost
$15, while a Fulper piece of this
scale would have cost only
about $1.

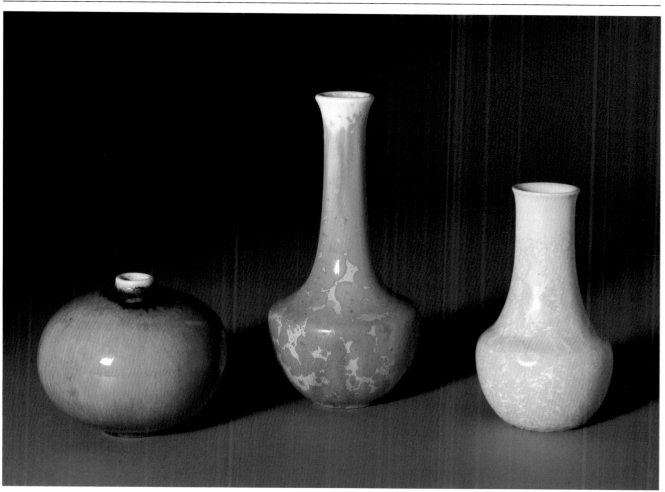

207 206 208

209.
Vase

Adelaide Alsop Robineau,
Syracuse, N.Y.
1924

White porcelain body, ovoid
form with high cylindrical neck;
high-gloss white crackle glaze
with blue edging dripping down
body, horizontal banding carved
in lower section with mat gray-
green glaze or stain

H. 12¾″; D. 6½″

Marks: circular raised *AR* cipher;
impressed date

Purchase 1926
26.18

Purchased for $70 from the
Pottery Shop in New York City,
this monumental vase represents
Robineau's later style, especially
in the heavy dripping glaze and
the carved horizontal banding.

99

210.
Vase

Rookwood Pottery,
Cincinnati, Ohio
1909

Decorated by
Charles (Carl) Schmidt

White clay body, tall ovoid cylindrical form with raised neck; black iris glaze shading from black at rim to royal blue at bottom, decorated with irises in gray-blues and greens front and back

H. 13¾"; D. 5½"

Marks: pottery mark for 1909 (impressed *RP* cipher with flames and roman numeral *IX*); *W* (white clay); shape number *907C*; Schmidt's cipher of interlocked *CS*; red and white rectangular paper Rookwood label with *RP* cipher and price $100

Purchase 1914
14.446

Perhaps the best-known piece in the Newark Museum's art pottery collection, this vase must have greatly charmed John Cotton Dana in order to have been purchased at the remarkable price of $100. Only a handful of pieces in the collection were as costly, and, like this example, all share some unique quality. Here the key seems to be the extraordinary black-to-blue glaze, one of the rarest on Rookwood. The limpid irises are typical of the flowers favored by the Art Nouveau and Arts and Crafts movements. The iris and the poppy were to the artisans of this era what the rose and the cluster of grapes were to the mid-nineteenth-century craftsmen.

211.
Vase

Rookwood Pottery,
Cincinnati, Ohio
1902

Decorated by
Matthew Andrew Daly

Yellow clay body, tall ovoid form
with raised neck; standard glaze
shading from brown to black to
olive to yellow to olive-brown,
painted with Scotch pine sprigs
and cones

H. 14″; D. 5½″

Marks: pottery mark for 1902
as above; shape mark *907C*;
Y (yellow clay); incised
M.A. Daly; paper Rookwood
label as above with price *$20*

Purchase 1914
14.444

Frederick Keer's Sons, an art
goods dealer in Newark, lent a
group of Rookwood pieces to
the Newark Museum for the
1910-11 exhibit of modern
American pottery. Three years
later the Museum purchased all
of the pieces still on loan, of
which this is one. Each of these
pieces retains its Rookwood
paper label with the price
affixed. Matt Daly worked at
Rookwood from 1882 until 1903.

212.
Puzzle Mug

Rookwood Pottery,
Cincinnati, Ohio
1894

Decorated by Sadie Markland

White body, hollow construction
with openwork rim; standard
glaze shading from olive to
black, decorated with a gremlin
in a dead tree

H. 5⅛"; O.W. 5¾"

Marks: pottery mark for 1894;
shape number *711*; *W* (white
clay); incised *SM*

Gift of
Mrs. R. M. Lowenthal 1925
25.1342

Sadie Markland worked at
Rookwood from 1892 until her
death in 1899. A puzzle mug was
designed so as to be impossible
to drink from without spilling
unless the user knew the secret
technique. This humorous form
dates back to the seventeenth
century.

213.
Vase

Rookwood Pottery,
Cincinnati, Ohio
1911

Decorated by Sara Sax

Pale green clay, ovoid cylindrical
form; overall vellum glaze of
charcoal gray at top shading to
dark olive-brown, with three
panels of stylized peacock
feathers on ochre ground

H. 8"; D. 3¾"

Marks: pottery mark for 1911 as
above; *G* (ginger clay), shape
number *939D*; *V* (vellum); Sax
cipher incised; paper Rookwood
label as above with price *$15*

Purchase 1914
14.448

Although executed in the same
year as Carl Schmidt's peacock
feather vase (see figure 217),
Sax here adopts the muted,
sober and more English Art
Nouveau (Arts and Crafts) style,
as opposed to Schmidt's more
opulent French manner.

214.
Ewer

Rookwood Pottery,
Cincinnati, Ohio
1902

Decorated by
Virginia B. Demarest

White clay, apple form with tall
neck flared to tricorner rim and
curved handle; standard glaze
shading from black to olive with
hawthorn(?) blossoms in rust,
yellow and green

H. 12½"; D. 6⅝"

Marks: pottery mark for 1902 as
above; shape number *578C*;
incised *VBD*; incised *X*, possibly
indicating glaze flaw

Gift of
Mr. and Mrs. John R. Hardin, Jr.
1950
50.140

Virginia Demarest worked at
Rookwood from 1900 until 1903.

215.
Bud Vase

Rookwood Pottery,
Cincinnati, Ohio
1901

Decorated by Fred Rothenbusch

White clay, flattened pear form
with flared rim; standard glaze
shading from brown to ochre,
decorated on front with seed
pods and leaves in tan, brown
and green

H. 4¾"; W. 3½"

Marks: pottery mark for 1901 as
above; shape number
883; *F*; *FTR* cipher

Gift of
Mr. and Mrs. Wilmot T. Bartle
1971
71.4

Rothenbusch worked at
Rookwood from 1896 until 1931.
On all Rookwood pieces the
decoration was applied *under* a
clear outer glaze.

216.
Vase

Rookwood Pottery,
Cincinnati, Ohio
1894

Decorated by Sadie Markland

White body, apple form with
trumpet-shaped neck; standard
glaze shading from deep
emerald green at rim to ochre to
black, decorated with four oak
leaves in ochre, orange and
brown

H. 7¾"; D. 4"

Marks: pottery mark for 1894;
shape number *753*; *W* (white
clay); incised *SM*

Gift of
Mrs. John R. Hardin 1971
71.2

The sophisticated underglaze
slip decoration used at
Rookwood was first developed
by Mary Louise McLaughlin,
inspired by the barbotine wares
produced in France and
displayed at the 1876 Centennial
Exposition. Rookwood became
famous for their decoration as
well as their lustrous glazes. The
early glazes were all glossy.

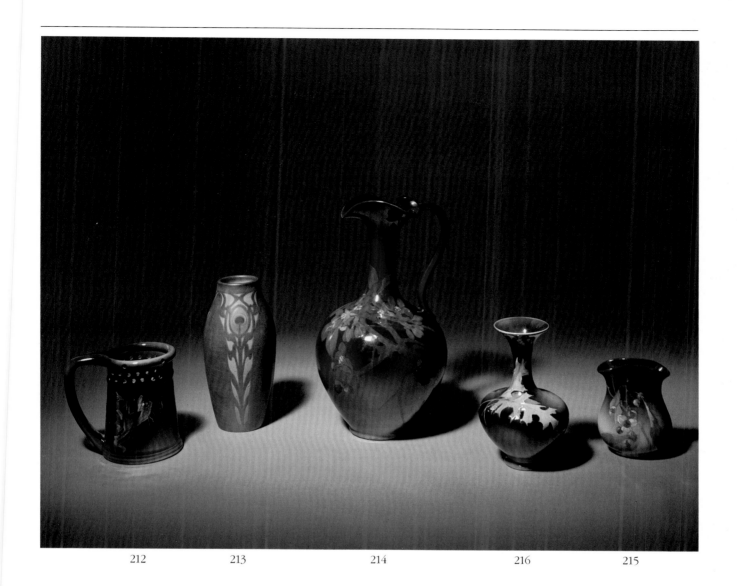

212 213 214 216 215

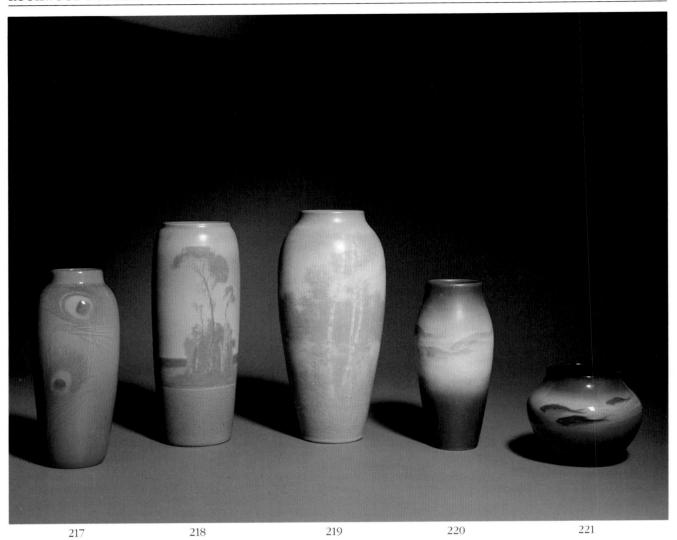

217 218 219 220 221

217.
Vase

Rookwood Pottery,
Cincinnati, Ohio
1911

Decorated by
Charles (Carl) Schmidt

White clay body, ovoid
cylindrical form; sky blue with
naturalistic peacock feathers

H. 8¾"; D. 3¾"

Marks: pottery mark for 1911 as
above; *W* (white clay); shape
number *907E*; Schmidt's cipher
of interlocked *CS*; paper
Rookwood label as above with
price *$20*

Purchase 1914
14.447

Charles Schmidt, who anglicized
his name from Carl, worked at
Rookwood from 1896 until 1927.
Compare his Art Nouveau style
peacock feathers with the
stylized Arts and Crafts version
of Sara Sax, done the same year
(see figure 213).

218.
Vase

Rookwood Pottery,
Cincinnati, Ohio
1909

Decorated by Fred Rothenbusch

White body, ovoid cylindrical
form; vellum glaze shading from
gray-blue to sky blue to cream,
with scene of oceanfront with
trees and moonrise

H. 10¾"; D. 4¼"

Marks: pottery mark for 1909; *V*
(vellum); shape number *951C*;
FTR cipher; paper Rookwood
label as above with price *$40*

Purchase 1914
14.449

Note the cost of this vase,
compared with the Matthew
Daly example (figure 211).
Although smaller, the more
difficult glaze made it twice as
expensive.

219.
Vase

Rookwood Pottery,
Cincinnati, Ohio
1913

Decorated by
Edward Timothy Hurley

White clay, ovoid cylindrical
form; overall vellum glaze
shading from gray to peach, with
gray-blue scene of woods and
silver birches with water beyond

H. 11¼"; D. 5¼"

Marks: pottery mark for 1913 as
above; *W* (white clay); *V*
(vellum); *ETH* cipher

Gift of
Mrs. Samuel Crossing 1983
83.1

To compare this piece with those
by Rookwood decorators
Sadie Markland and
Virginia Demarest is to
understand how, even within its
own sphere, Rookwood had
followed changing fashions in
pottery design and decoration.
Although the mood and hues
retain some of the Japonism of
the nineteenth century, this vase
is far removed stylistically, if not
intellectually, from the late
Victorian work of Ott and
Brewer and Edward Lycett of
Faience Manufacturing.

220.
Vase

Rookwood Pottery,
Cincinnati, Ohio
1905

Decorated by
Edward Timothy Hurley

Pale green clay, tall ovoid form;
sea-green vellum glaze shading
from olive to aquamarine to
creamy tan-green, decorated
with five fishes in gray and pink

H. 7¾"; D. 3½"

Marks: pottery mark for 1905 as
above; shape number *80E*; *V*
(vellum); incised *E.T. Hurley*

Gift of
Mrs. Arthur S. Luria 1941
41.137

Hurley worked at Rookwood
from 1896 to 1948. The vellum
glaze was first perfected in about
1904 (Peck 1968, 73), and was
first displayed at the St. Louis
World's Fair. It was a mat *clear*
glaze, unlike anything else
produced in America, and gave a
velvety finish to the ware.

221.
Vase

Rookwood Pottery,
Cincinnati, Ohio
1909

Decorated by
Edward Timothy Hurley

White clay, squat ovoid form
with raised neck; sea-green glaze
shading from dark olive to pale
blue-green, painted with five
small fishes in greens and grays

H. 4"; D. 4¾"

Marks: pottery mark for 1909 as
above; shape mark *906*; incised
ETH cipher

Purchase 1914
14.445

Although the original paper
label is lost from this piece, the
1914 retail cost would have been
approximately $12.

222.
Vase

Rookwood Pottery,
Cincinnati, Ohio
1923

Decorated by
Kataro Shirayamadani

White clay body, squat ovoid
form with slightly raised rim;
orchid glaze shading from sky
blue to pink, decorated with
cherry blossoms on shoulder

H. 4"; D. 4⅜"

Marks: pottery mark for 1923 as
above; shape number *890E*;
incised calligraphic mark of
artist

Purchase 1981
W. Clark Symington
Bequest Fund
81.30

Shirayamadani came to work for
Rookwood in 1887 and stayed
until his death in 1948. He
brought much of the Japanese
aesthetic to the pottery's
decoration, and his work is
highly sought after today.

223.
Bowl

Rookwood Pottery,
Cincinnati, Ohio
1928

Decorated by Lorinda Epply(?)

White clay, deep hemispherical
form; black drip glaze at rim
above ground of cream with
stylized geometric flowers in
blurred pastel shades

H. 5"; D. 5"

Marks: pottery mark for 1928 as
above; possible remains of
painted cipher (illegible)

Purchase 1929
29.1357

Purchased at Bamberger's in
Newark for $15, this bowl
represents Rookwood's later
years, both in the Art Deco
design of the form and
decoration and in the pastel
colors so typical of the period.
The attribution to Lorinda Epply,
who worked at Rookwood from
1904 to 1948, is based on stylistic
similarities (Trapp 1983).

224.
Vase

Rookwood Pottery,
Cincinnati, Ohio
1928

White clay body, eggplant shape;
overall striated oxblood glaze

H.. 6½"; D. 4½"

Marks: pottery mark for 1928 as
above; shape number *2726*;
partial Bamberger's (Newark)
store sticker

Purchase 1929
29.1356

A longstanding goal of art
potters was the attainment of a
good Chinese oxblood glaze.
Hugh Robertson achieved it at
Dedham in the 1890s, and
Rookwood sold many pieces in
this prized color during the
1920s, when Chinese K'ang Hsi
and Ch'ien L'ung porcelains
were very much in vogue in
American decoration. Priced at
$20, this piece cost more than
the elaborately decorated bowl,
attributed to Lorinda Epply,
indicating the continuing cachet
of the oriental look. The simple
classic form and the subtle,
richly-colored glaze (a Chinese
turquoise was equally popular)
adapted as well to the Art Deco
and colonial revival interiors of
the 1920s as they had to the Arts
and Crafts interiors of the 1890s
through the 1910s.

225.
Jug

Rookwood Pottery,
Cincinnati, Ohio
1882

Executed by Harriet Wenderoth

Fine gray stoneware; carved
Japanesque decoration showing
cherry blossoms and branches
in a circle above a rectangle with
grasses

H. 5"; W. 3½"

Marks: impressed
ROOKWOOD/1882; incised *HW*

Purchase 1981
W. Clark Symington
Bequest Fund
81.32

The American art pottery
movement began in Cincinnati,
inspired by the oriental and
French wares at the 1876
Centennial Exhibition, and
further motivated by the English
aesthetic reform movement led
by William Morris and his peers.
The first new art wares were
produced at the Rookwood
Pottery, established by
Maria Longworth Nichols in
1880, and had a great effect on
the development of American
pottery. Harriet Wenderoth
worked as a decorator at
Rookwood from 1881 to 1885,
and in this piece demonstrates
the Japonism which so
influenced Rookwood's early
wares.

226.
Cream Jug

Rookwood Pottery,
Cincinnati, Ohio
1886

Designed by Kate Wood

Tan earthenware; buff slip glaze
incised with Japanesque leaves
and gilt

H. 2⅜"; W. 4¾"

Marks: impressed
ROOKWOOD/1886; G (ginger
clay); shape number *43*

Purchase 1981
W. Clark Symington
Bequest Fund
81.33

Part of a tea set designated as
"Japanese" in the Rookwood

shape book (Peck 1968, 150),
this cream jug represents the
popular table wares and small
articles produced in quantity by
Rookwood in its early years. The
square form as well as the style
of decoration relate to the
orientalizing taste of the 1880s,
but the hand-hewn feeling and
conscious crudeness of the piece
relate more to subsequent Arts
and Crafts notions.

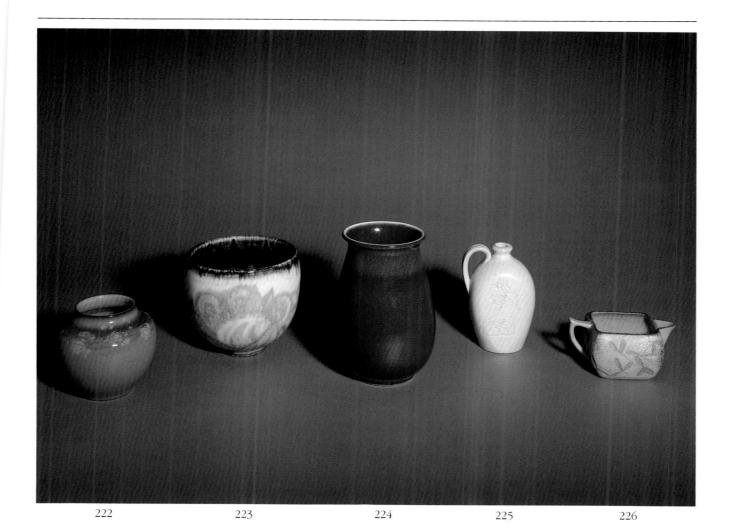

222 223 224 225 226

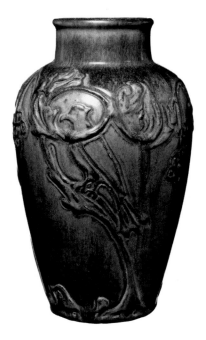

227.
Vase

Rookwood Pottery,
Cincinnati, Ohio
1915

Decorator unknown

White clay body, molded
baluster form with pattern of
vines and three birds; overall
mat glaze of a striated blue and
green with glossy highlights

H. 9½"; D. 5½"

Marks: pottery mark for 1915 as
above; shape number *1204*

Purchase 1971
Thomas L. Raymond
Bequest Fund
71.67

This interesting piece, from one
of Rookwood's more commercial
lines, relates closely to
contemporary work by Grueby
or even Fulper, with its muted
dripping glazes and shallow
molded design.

228.
Mug

Rookwood Pottery,
Cincinnati, Ohio
1907

Decorator unknown

Cream body, flared cylindrical
form with applied oval handle;
sky blue vellum glaze with
incised clouds highlighted in
cream

H. 7¼"; D. 5"

Marks: pottery mark for 1907 as
above; *V* (vellum); shape number
1014D; illegible *WO* or possibly
VVO cipher

Gift of
Mrs. R. M. Lowenthal 1925
25.1343

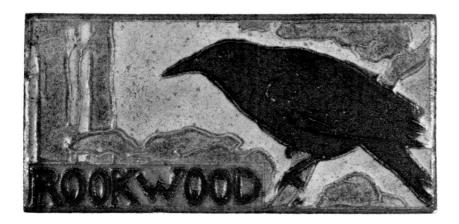

229.
Plaque

Rookwood Pottery,
Cincinnati, Ohio
ca. 1910

Buff earthenware with shallow
relief decoration of a rook and
the company name; mat glazes
in tan, brown, navy and olive

H. 4½"; L. 8⅞"

Marks:
ROOKWOOD/FAIENCE/1622
impressed on back; paper
Rookwood label as above
attached to side with price *$3.00*

Purchase 1911
11.450

This rare tile, intended by the
pottery as an advertisement shelf
plaque, was probably sold as a
souvenir to tourists, and was
part of the Museum's 1910-11
exhibit, *Modern American
Pottery*.

230.
Vase

Roseville Pottery,
Zanesville, Ohio
ca. 1920-30

Earthenware body, ovoid form
with slightly flared rim, molded
with relief ornament of
dogwood blossoms and
branches; mat green ground
with blossoms in white

H. 6¼"; D. 5½"

Mark: printed *V* within *R* cipher
in blue

Purchase 1971
Thomas L. Raymond
Bequest Fund
71.74

Along with Weller, Roseville was
one of the more successful
imitators of Rookwood pottery,
and produced many high quality
pieces along the lines of
Rookwood's slip-decorated
wares. In their later period they
produced many molded
patterns, commonly using floral
motifs. The dogwood pattern is
one of their most popular.
Although technically art pottery,
this type of ware retains true art
pottery status on only a marginal
level, as much of the art pottery
ideal has been lost through mass
production. Rookwood also
produced inexpensive mass-
market molded wares in the
same period, although their
production of hand-decorated
goods continued until the very
end of the firm's history.

231 234 232 233

231.
Bowl

Paul Saint-Gaudens,
Brooklyn, N.Y.
1924

Red earthenware with straight
sides and flared rim; overall drip
glaze of soft blues and greens,
speckled with blue and brown

H. 4½"; D. 8¼"

Mark: incised
PAUL/ST.GAUDENS/B.1924

Purchase 1924
24.197

Paul Saint-Gaudens was the
nephew of famed sculptor
Augustus Saint-Gaudens. In 1921
he founded the Orchard Kilns
with his mother, Annette, in
Cornish, New Hampshire (Davis
1974, 54-6). In 1923 Paul studied
pottery with Oscar Bachelder in
Candler, North Carolina, and
then moved to Brooklyn in 1924.
There he opened his own
pottery. The Newark Museum
gave Paul and Annette
Saint-Gaudens a show in 1924,
and subsequently bought these
three pieces from him, plus a
small vase by Bachelder. This
bowl, which cost only $5, was
far less expensive than other
examples of Saint-Gaudens'
work. Only recently has the
Museum acquired one of his
more ambitious sculptural
pieces. Paul returned to New
Hampshire in 1925. He died in
1954.

232.
Vase

Paul Saint-Gaudens,
Brooklyn, N.Y.
1924

Red earthenware, broad baluster
form on raised foot; medium
blue and gray drip glaze on
exterior, gray-white interior
glaze

H. 6½"; D. 7"

Mark: Museum label reading
St. Gaudens

Purchase 1924
24.198

The original price of this vase
was $10.

233.
Vase

Paul Saint-Gaudens,
Brooklyn, N.Y.
1924

Red earthenware, globular bottle
form with narrow flared neck;
upper section has medium blue
streaked glaze dripping to
crackled white

H. 5¼"; D. 6¼"

Mark: incised
P.S.G./BROOKLYN/1924

Purchase 1924
24.199

The original price of this vase
was $6.

234.
Vase

Paul Saint-Gaudens,
Brooklyn, N.Y.
1924

Red earthenware, broad baluster
form with sculptured handles in
form of winged caryatids; overall
soft gray glaze speckled with
blue and brown

H. 9"; D. 7"

Mark: incised
*PAUL/ST. GAUDENS/
BROOKLYN/1924*

Purchase 1978
Thomas L. Raymond
Bequest Fund
78.120

Because of its 1924 date, this
monumental sculpted vase
might well have been one of
the pieces exhibited at the
Newark Museum's show of
Paul Saint-Gaudens' work in
1924, one of those examples
then seen as too expensive to
buy for the collection. The
sculptural handles are typical of
the more ambitious work of
both Paul and Annette in the
1920s.

235.
Rose Bowl

School of Mines, University of
North Dakota, Grand Forks, N.D.
1935

Executed by Koch

Buff earthenware body, squat
ovoid form; overall mottled rose
glaze with incised band of pink
cherry blossoms at top
highlighted in green, with green
interior glaze

H. 4¼″; D. 5¾″

Marks: printed blue circular
mark *UNIVERSITY OF NORTH
DAKOTA/MADE AT/SCHOOL OF
MINES/N.D. CLAY/
GRAND FORKS, N.D.*; incised
KOCH-1935

Purchase 1971
Thomas L. Raymond
Bequest Fund
71.75

Although the School of Mines
pottery is unknown today, it was
clearly a counterpart of Binns'
school at Alfred University and
Walrath's Mechanics Institute.

236.
Vase

Tiffany Pottery, Corona, N.Y.
ca. 1905-14

Designed by
Louis Comfort Tiffany

White earthenware body,
tapered cylinder form molded in
shape of unfurling fiddlehead
fern fronds; overall mottled pale
green mat and glossy glaze

H. 9¼″; D. 5″

Mark: incised *LCT* cipher

Purchase 1975
Wallace M. Scudder
Bequest Fund
75.160

Louis Tiffany was not a potter,
but a brilliant designer. His
work, related to the organic
aesthetic of Grueby, Fulper and
Van Briggle, reflects the same
strong Art Nouveau style.
Tiffany's pottery seems not to
have been as popular as his
more famous Favrile glassware,
and ceased to appear after
about 1914.

237.
Tile Panel

Trent Tile Company, Trenton, N.J.
ca. 1885-90

White earthenware molded with
four-part scene of shepherdess
in classical garb; overall mottled
blue-green and tan translucent
glaze

Each 6″ sq.

Mark: *TRENT* in relief (on each
tile)

Gift of
Mr. and Mrs. Homer Kripke 1980
80.76A-D

Issac Broome also worked for
the Trent Tile firm, and may
have had a hand in the design of
this series, which is said to have
been part of a mantel surround
in the Potter Palmer castle in
Chicago (built 1885).

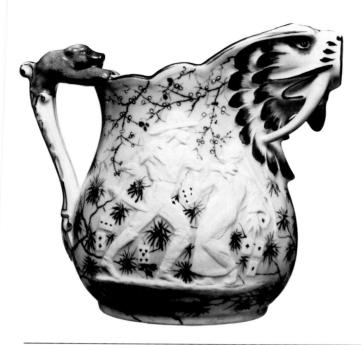

238.
Pitcher

Union Porcelain Works,
Brooklyn, N.Y.
ca. 1876

Designed by Karl Müller

Porcelain body molded with
walrus-head spout and bear
handle, with relief scenes on
each side; overglaze painted
orientalized decoration

H. 10"; O.W. 10¾"

Marks: impressed *U.P.W.* in
barrel on side; *UNION/
PORCELAIN/ WORKS/
GREENPOINT/N.Y.* painted on
bottom

Purchase 1968
68.109

Although far removed from the
austerity of later art pottery, the
first influences of the aesthetic
reform movement are already
evident in this monumental
pitcher, especially in the overall
painted-on Japanesque branch
decoration. The ironically anti-
Chinese sentiments depicted in
the scene on one side were
drawn from Bret Harte's 1870
poem, "Plain Language from
Truthful James." The use of the
pitcher's body as a base for
sculptural work shows the
importance of the modeler-
designer and his influence on
the form of a piece of ceramic.
This object represents the first
vision of a piece of ceramic as a
potential work of art; not the
same vision of later decades, but
a significant first step.

239.
Mug

Van Briggle Pottery,
Colorado Springs, Co.
1902

Executed by Artus Van Briggle

White earthenware body, ovoid
form with D-shaped handle; mat
glaze shading from medium
blue at top to apple green at
bottom

H. 5¼"; O.W. 5½"

Marks: incised pottery cipher
and name; date *1902/III*

Bequest of
John Cotton Dana 1931
31.729

Newark borrowed fourteen
pieces of Van Briggle pottery
from the dealer Oliver Olson in
New York City for the 1910-11
exhibition, *Modern American
Pottery.* The Museum ultimately
purchased only two works from
the show. John Cotton Dana
himself purchased three
additional pieces, which are now
in the Museum's collection. Van
Briggle established his pottery in
Colorado in 1901, after leaving
Rookwood because of
tuberculosis. He died in 1904.

240.
Bowl

Van Briggle Pottery,
Colorado Springs, Co.
1903

White earthenware, globular
form; overall mat glaze shading
from deep rose at rim to sky
blue on body

H. 4⅜"; D. 4¾"

Marks: cipher; incised name of
pottery; date *1903*

Bequest of
John Cotton Dana 1931
31.730

241.
Vase

Van Briggle Pottery,
Colorado Springs, Co.
1903

Executed by Artus Van Briggle

White earthenware, swelling
cylindrical form molded in relief
with tall iris flowers; overall mat
glaze of apple green with blush
of red on each of the three
flowers

H. 11½"; D. 4"

Marks: cipher; incised name of
pottery; date *1903/III*

Purchase 1929
29.1003

Purchased from the estate of
John Cotton Dana, this important
vase reflects Van Briggle's best
early work in glazes and relief
molding.

242.
Vase

Van Briggle Pottery,
Colorado Springs, Co.
ca. 1905-10

Buff earthenware, tapered
cylindrical form with narrow
neck, neck and shoulder molded
with arches, leaves and berries;
overall dark olive mat glaze

H. 10¼"; D. 4"

Marks: incised cipher; partial red
and white pottery label with
printed cipher and price *$6.00*

Purchase 1911
11.510

This vase was purchased for
the 1910 exhibition from
Oliver Olson in New York City.
Van Briggle's widow, Anne,
carried on the pottery
successfully after his death.

243.
Flower Bowl

Van Briggle Pottery,
Colorado Springs, Co.
ca. 1910

Buff earthenware, squat bulbous
form; overall mat glaze of deep
rose-rust

H. 3⅞"; D. 7½"

Marks: cipher; incised pottery
name and city name

Purchase 1911
11.511

This bowl was shown in the
1910-11 exhibition.

244.
Vase

Van Briggle Pottery,
Colorado Springs, Co.
1917

Buff earthenware, tapered
cylindrical form, relief molded
with five columbines vertically
dividing body; overall mat glaze
of marbled dark blue over
turquoise with brown highlights.

H. 10½"; D. 4½"

Marks: incised cipher; date *1917*

Purchase 1971
Frederick P. Field Bequest Fund
71.3

A rare and unusual glaze
decorates this Van Briggle vase.

245.
Vase

Van Briggle Pottery,
Colorado Springs, Co.
1905

Red earthenware body, bottle
form with narrow neck; overall
robin's-egg-blue mat glaze

H. 7⅜"; D. 3⅞"

Marks: incised cipher and
pottery name; date *1905/XV*

Gift of
Jack T. Ericson 1971
71.60

The use of a red body for this
piece is unusual.

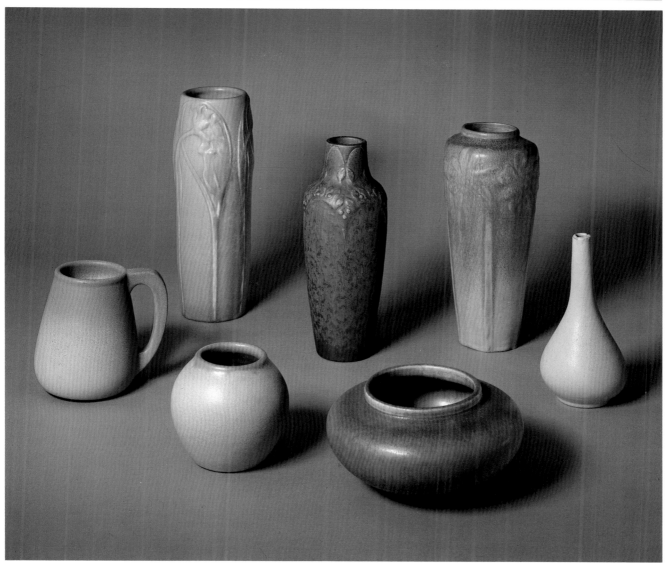

239 241 242 243 244 245
 240

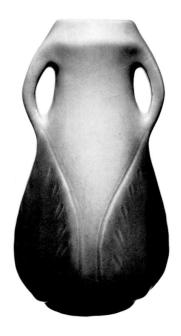

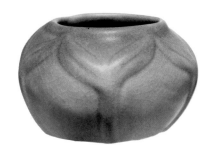

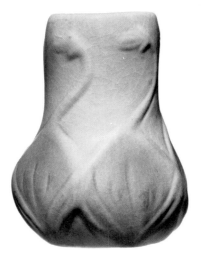

246.
Vase

Van Briggle Pottery,
Colorado Springs, Co.
ca. 1920-30

White earthenware, pear-shaped
body with two small handles;
mat light green and blue glazes

H. 9¼"; D. 4½"

Marks: incised cipher, pottery
name and *U.S.A.*

Purchase 1971
Thomas L. Raymond
Bequest Fund
71.76

Old designs were used long
after Artus Van Briggle's death.
Although dating from the 1920s,
this piece was probably made
from one of the pre-1910 molds.
It is of good quality, better than
much of the late Van Briggle
wares.

247.
Rose Bowl

Van Briggle Pottery,
Colorado Springs, Co.
ca. 1920-30

White earthenware, globular
form with molded leaves
creating five ogee arches; mat
glaze of medium blue shading to
light blue-green

H. 2¼"; D. 3½"

Marks: incised cipher, pottery
name and city name

Gift of
Jack T. Ericson 1971
71.62

248.
Vase

Van Briggle Pottery,
Colorado Springs, Co.
ca. 1920-30

White earthenware, pear-shaped
body molded with swirling leaf
and bud motifs; mat glazes in
shades of light blue-green and
medium blue

H. 4¾"; D. 3½"

Marks: incised cipher, pottery
name and city name

Gift of
Jack T. Ericson 1971
71.61

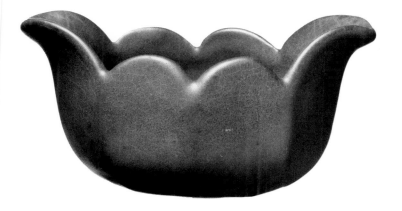

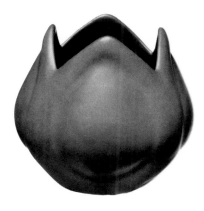

249.
Bowl

Van Briggle Pottery,
Colorado Springs, Co.
ca. 1930

White earthenware, oval form
with scalloped rim and flared
ends; overall mat maroon glaze

H. 2¾"; L. 5¼"

Marks: incised cipher, pottery
name and city name

Gift of
Jack T. Ericson 1971
71.62

250.
Bowl

Van Briggle Pottery,
Colorado Springs, Co.
ca. 1930

White earthenware, partly
opened four-petal tulip form;
maroon and dark blue mat
glazes

H. 3⅝"; D. 3¾"

Marks: incised cipher, pottery
name and city name

Gift of
Jack T. Ericson 1971
71.58

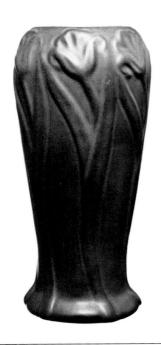

251.
Vase

Van Briggle Pottery,
Colorado Springs, Co.
ca. 1920-30

White earthenware, tall tapered
form on flared foot molded with
design of tulips in relief; mat
glazes of maroon and dark blue

H. 9⅝"; D. 4½"

Marks: incised cipher, pottery
name and city name

Purchase 1977
The Members' Fund
77.432

252.
Vase

Volkmar Kilns, Metuchen, N.J.
ca. 1910

Executed by Charles or
Leon Volkmar

Buff earthenware, tall cylindrical
form with evident wheel marks;
overall blue-black mat glaze

H. 14"; D. 4½"

Marks: incised *Volkmar/1910*

Purchase 1911
11.507

Newark borrowed fourteen
pieces from the Volkmar Kilns in
1910. The Museum purchased
three pieces from the exhibit
(this one for $12), and were later
given a large scenic tile.
Charles Volkmar and his son
Leon ran their pottery in
Metuchen, New Jersey, from 1903
until 1911, when Leon became
involved in the Durant Kilns.
Charles continued the
New Jersey operation until his
death in 1914. This tall vase
exemplifies the simple forms
and carefully worked-out glazes
which characterize the Volkmar
pottery of this period.

253.
Vase

Volkmar Kilns, Metuchen, N.J.
ca. 1910

Executed by Charles or
Leon Volkmar

Buff earthenware body, squat
baluster form; overall scaly leaf-
green glaze with molten effect

H. 6⅛"; D. 5¼"

Marks: incised *V*

Purchase 1911
11.509

The price in 1911 was $6.

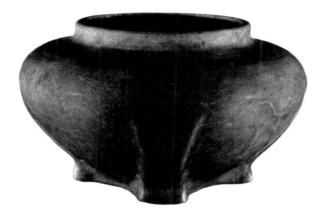

254.
Lamp Base

Volkmar Kilns, Metuchen, N.J.
ca. 1910

Executed by Charles or
Leon Volkmar

Buff earthenware, squat ovoid
form with four buttress-like feet
and shallow raised rim; overall
mat glaze of deep brick red,
interior with speckled gray-blue
glaze

H. 5¼"; D. 9"

Mark: incised *V* and *Volkmar*

Purchase 1911
11.508

This piece, purchased for $8,
was described as a lamp base,
although it was not drilled to
receive a wire. As on pottery
lamp bases by Grueby or Fulper,
the wire often extended directly
from the fixture socket to avoid
damaging the base by drilling.

255.
Scenic Tile

Volkmar Kilns, Metuchen, N.J.
ca. 1910

By Leon Volkmar (?)

Buff earthenware with scene of
five birch trees at dusk; mat
glazes in shades of green and
brown

7¾" sq.

Marks: signed *V* on face;
*VOLKMAR KILNS/
METUCHEN, N.J.*
stamped in ink on reverse

Gift of
William B. Kinney 1911
11.466

Charles Volkmar and his son
Leon lent several pieces to the
Museum's 1910-11 exhibit. The
donor of this important scenic
tile purchased it from the
exhibition for $25 and gave it to
the collection.

256.
Vase

William Joseph Walley,
West Sterling, Ma.
ca. 1913-14

Dark brown earthenware body,
globular form with raised neck;
heavy deep green and brown
mottled mat glaze with volcanic
dripping

H. 6⅝"; D. 6⅜"

Marks: impressed *W.J.W.*; label of
the Society of Arts and Crafts,
Boston, with price *$7.50*

Purchase 1914
14.923

Walley was born in the pottery
center of East Liverpool, Ohio, in
1852, and worked in England at
the Minton Works before

returning to the United States in
1873. He bought a defunct
pottery in West Sterling,
Massachusetts, and produced a
limited line of art ware from
local red clays, doing all the
work himself. He died in 1919.
His work is rather rare today.
Newark's example is particularly
fine, with a superlative volcanic
green glaze.

257.
Paperweight

Frederick E. Walrath,
Rochester, N.Y.
ca. 1910

Buff stoneware molded in form
of a sea turtle; mat dark green
glaze

L. 3⅞"

Marks: incised *Walrath/Pottery*;
incised *MI* (Mechanics Institute)
cipher; price tag *75¢*

Bequest of
John Cotton Dana 1929
29.1002

Frederick Walrath was a student
of Charles Binns at Alfred
University. He had gone on to
become a ceramics teacher at
the Mechanics Institute in
Rochester when the Museum
requested he send some pieces

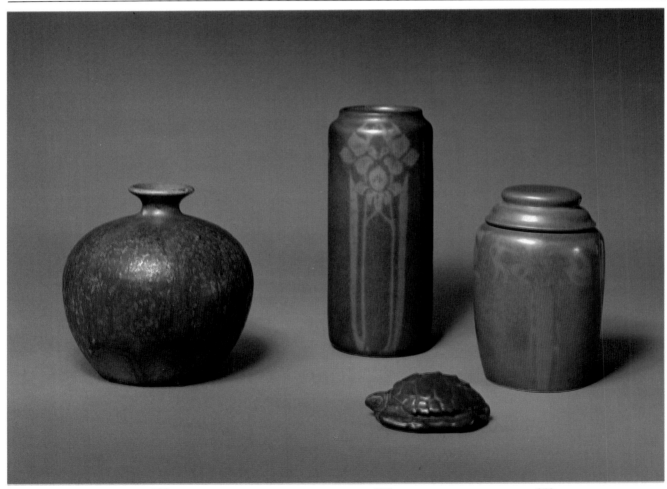

256 258 259
257

for the *Modern American Pottery* exhibition. This turtle was purchased from the 1910-11 show by the Museum's director, John Cotton Dana, who bequeathed it to the permanent collection in 1929. The Museum borrowed twenty-two Walrath pieces for the exhibition, about which the potter commented that they were not his best, but were representative of his techniques and glazes (Newark Museum archives). Walrath later left Rochester for the Newcomb College Pottery in New Orleans, where he remained until his death in 1920.

258.
Vase

Frederick E. Walrath,
Rochester, N.Y.
ca. 1910

Buff stoneware, cylindrical form; overall finely mottled dark green satin glaze, three stylized irisis in olive, tan and deep red, dark brown mat interior glaze.

H. 9"; D. 3¾"

Marks: incised *Walrath/Pottery*; *MI* cipher; paper price tag *$6.00*

Purchase 1911
11.505

Compare this piece with Carl Schmidt's 1909 iris vase for Rookwood. The difference in the depiction of the flower shows the simultaneous popularity of the dry stylization of the English Arts and Crafts school and the luxurious naturalism of the French Art Nouveau.

259.
Jar with Cover

Frederick E. Walrath,
Rochester, N.Y.
ca. 1910

Buff stoneware, cylindrical form with domed lid; overall finely mottled olive-brown satin glaze, stylized foliate decoration on front and back in deep tan, tan mat interior glaze

H. 6¾"; D. 4⅜"

Marks: incised *Walrath/Pottery*; *MI* cipher

Purchase 1911
11.506

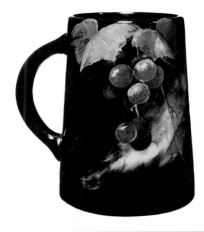

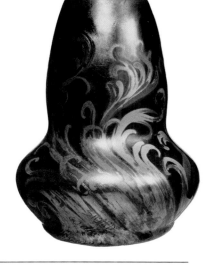

260.
Mug

Weller Pottery, Zanesville, Ohio
ca. 1900-10

Buff earthenware, tapered cylindrical form with C-shaped handle; dark brown to black glaze with green and olive-brown grape cluster

H. 6"; O.W. 6"

Marks: signed *ER* near handle base; impressed *WELLER*; incised *Aurelian* in script

Gift of
Mrs. R. M. Lowenthal 1925
25.1344

Weller was among the many imitators of Rookwood, and achieved much high quality work, competing successfully with Rookwood's standard glaze.

261.
Vase

Weller Pottery, Zanesville, Ohio
ca. 1901-07

Decorated by Jacques Sicard

White earthenware, gourd form; overall iridescent purple-gold glaze with swirling tendrils in iridescent green-gold

H. 6¾"; D. 5"

Marks: *Sicard/Weller* signed near base

Purchase 1971
Thomas L. Raymond
Bequest Fund
71.72

In 1902 Weller hired Jacques Sicard, a French decorator, to produce a line of iridescent wares, among the most original of any produced in an American pottery.

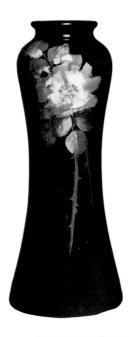

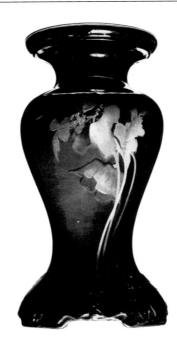

262.
Lamp Base

Weller Pottery (?),
Zanesville, Ohio
1890-1910

Buff earthenware, tapered
cylindrical form; dark brown
overall glaze with slip painted
rose in brown, tan and green

H. 10½"; D. 4¼"

Marks: incised *A* and *X*

Gift of
Mr. and Mrs. Homer Kripke 1980
80.74

263.
Plant Stand

Weller Pottery (?),
Zanesville, Ohio
1890-1910

Buff earthenware, baluster form
with relief-molded oak leaves at
base; overall glaze shading from
black to brown to olive with slip
painted sweet pea plant on front
in brown, tan and green

H. 18½"; D. 9¾"

Unmarked

Gift of
Mr. and Mrs. Homer Kripke 1980
80.73

Arnest, Barbara M., ed. *Van Briggle Pottery, The Early Years*. Colorado Springs: Colorado Springs Fine Art Center, 1975.

Barber, Edwin Atlee. *The Pottery and Porcelain of the United States*. 1909. *Marks of American Potters*. 1904. Reprint (2 books in 1). New York: Feingold and Lewis, 1976.

Blasberg, Robert. *The Ceramics of William H. Grueby*. Syracuse, New York: The Everson Museum of Art, 1981.

Blasberg, Robert, and Carol Bohdan. *Fulper Pottery: An Aesthetic Appreciation, 1909-1929*. New York: The Jordan-Volpe Gallery, 1979.

Clark, Garth, and Margie Hughto. *A Century of Ceramics in the United States, 1878-1978*. Syracuse, New York: The Everson Museum of Art, 1981. New York: E.P. Dutton, 1979.

Clark, Robert Judson, ed. *The Arts and Crafts Movement in America, 1876-1916*. Princeton: The Art Museum, 1972.

Davis, Chester. "The Orchard Kilns of Paul Saint-Gaudens." In *Spinning Wheel* (March 1974), pp. 54-56.

Evans, Paul. *Art Pottery of the United States; An Encyclopedia of Producers and Their Marks*. New York: Charles Scribner's Sons, 1974.

————. "Newcomb Pottery Decorators." In *Spinning Wheel* (April 1974), pp. 54-55.

Keno, Leigh. "Odell and Booth Brothers." In *Art and Antiques* 3 (March/April 1980), pp. 96-101.

Kovel, Ralph and Terry. *The Kovels' Collectors' Guide to American Art Pottery*. New York: Crown Publishers, 1974.

Peck, Herbert. *The Book of Rookwood Pottery*. New York: Crown Publishers, 1974.

Trapp, Kenneth. *Toward the Modern Style: Rookwood Pottery, The Later Years, 1915-1950*. New York: The Jordan-Volpe Gallery, 1983.

Weiss, Peg., ed. *Adelaide Alsop Robineau, Glory in Porcelain*. Syracuse, New York: The Everson Museum of Art, 1981.